Power *and* Paper:

MARGARET BOURKE-WHITE, MODERNITY, AND THE DOCUMENTARY MODE

Boston University Art Gallery

855 Commonwealth Avenue

Boston, Massachusetts 02215

© 1998 by Trustees of Boston University

Printed in the United States of America

Library of Congress Catalogue Card Number: 97-77774

ISBN: 1-881450-09-0

Distributed by the University of Washington Press

P. O. Box 50096, Seattle, Washington 98145

COVER ILLUSTRATION: **MARGARET BOURKE-WHITE,** *Untitled,* gelatin silver print, 1937

Power *and* Paper:

MARGARET BOURKE-WHITE, MODERNITY, AND THE DOCUMENTARY MODE

Exhibition and catalogue by
John R. Stomberg

Introduction by
Kim Sichel

Boston University Art Gallery
March 6–April 12, 1998

University of Washington Press ❐ *Seattle and London*

Contents

Acknowledgments

Power and Paper: Margaret Bourke-White, Modernity, and the Documentary Mode would not have been possible without the generous contribution and support of many individuals and institutions. We would foremost like to express our gratitude to International Paper and the International Paper Company Foundation for helping to underwrite this exhibition. We also thank Syracuse University Library, Department of Special Collections, for lending to the exhibition and Carolyn Davis and Mark Weimar for their cooperation and support. In addition, we would like to express our thanks to Jonathan White of the Margaret Bourke-White Estate; his willingness to help is greatly appreciated. We also acknowledge Time Life Syndication for permission to use images that appeared in their publications. We are grateful for the research assistance of Katrina Jones, whose enthusiasm and dedication to the project was an immeasurable help. We also thank the gallery staff this year, including Evelyn Cohen, Amy Daughenbaugh, Katie Delmez, Riva Feshbach, Julie Marchenko, Stacey McCarroll, Andrew Tosiello, and Francesca Tronchin.

Kim Sichel
Director

John R. Stomberg
Assistant Director

Gelatin silver print
1930
13 ¹/₄ x 9 ¹/₄ inches

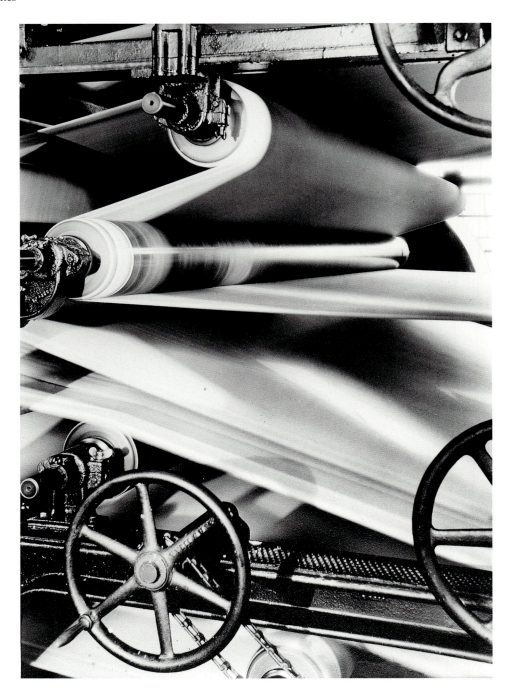

Corporate Culture and Photographic Books

Kim Sichel

PHOTOGRAPHY HAS BEEN INEXTRICABLY INTERTWINED with corporate culture and with the medium of the book narrative throughout its history. Photographs emphasize formal attributes—detail, repetition, precision, pattern—that are an effective counterpart to industry's ideological enthusiasm for rationalization, factory production, and technological advance. Books can carry these messages even further. A child of the industrial revolution, the photographic medium seems suited both mechanically and ideologically to record progress. It includes lenses developed in imitation of Renaissance perspective, chemical processes to capture the imprint of light upon paper, and negative and print materials to highlight detail and precision in their imagery. Even the camera itself—a machine incorporating metal, glass, wood, and various mechanically moving pieces—is an industrial tool. When cameras and corporations join to create books and other narratives, a powerful cultural commentary on industrialization can result.

These partnerships were constructed in a variety of ways. Some companies hired photographers directly, and some photographers worked on speculation and sold images to the sponsors independently. The degree of autonomy allowed the photographer also varied. Many books emerged under the direct supervision of their companies, photographed by staff photographers under the clear control of their corporate bosses. Others evolved under a looser alliance, and photographers hired for special commissions sometimes enjoyed greater freedoms in interpreting their subjects. The collaborations reached imaginative and luxurious proportions by the golden age of the machine, the period between the two world wars. Business photography, especially in the form of the photographic corporate report, was in its heyday. In 1937, Margaret Bourke-White undertook her mammoth commission to document International Paper and Power's Canadian newsprint operations, creating a body of images and a book that form the subjects of this exhibition.

Scholars have not yet systematically explored corporate publications that present photographs as a marketing tool. Yet these books reveal much about the interaction of culture and commerce during these years. Many photographers collaborated with industry, and the body of imagery that evolved is only now beginning to surface in business libraries and archives. Many of the most powerful photographers of the interwar years routinely accepted corporate commissions. Their generally positive but independent imagery for their business clients tells a complex story of the effect of business culture on society. As they become better known, these

9

newly rediscovered corporate publications are helping to revise the long-held notion that modern artists (and especially photographers) normally operated in opposition to popular culture.

Literary critic Andreas Huyssen has begun to rewrite the modernist myth that art must exist at the opposite pole from mass culture, defining instead a "historical avant-garde," that "aimed at developing an alternative relationship between high art and mass culture and thus should be distinguished from modernism, which for the most part insisted on the inherent hostility between high and low."[1] The beauty of the collaborations between corporate clients and their modernist record-keepers, however, suggests that the liaison between artists and businesses benefited both parties. Photographic capitalism—the selling of business goods or ideas through the persuasive medium of the photographic print—was particularly effective when the topic was industry.

By the 1920s, the technological developments in photography—coupled with innovative formal experimentation by photographers—allowed imaginative collaborations. Corporate clients who engaged photographers ranged from car companies (such as Ford, Citroën, and Peugeot) to the steel industry (encompassing both American and German companies such as Krupp). For instance, when Charles Sheeler photographed Ford's new River Rouge plant in 1927, the company hired him as much because they respected him as a creative photographer as for his technical skills. He was given a general mandate, but allowed far greater freedom to interpret his corporate subject than many other companies would allow. The greater freedoms reflected the broad-mindedness and creativity of certain corporations, but also the relative prosperity of the late 1920s. German photographers such as Albert Renger-Patzsch and Germaine Krull, Americans such as Bourke-White and Sheeler, and their numerous colleagues in France, Britain, and other countries found work as corporate photographers with great regularity.[2]

Photographs proved to be a powerful advertising and promotional tool in the interwar years. Their clarity, the cool and precise quality of the 1920s modernist style, and the black and white beauty of precisionist photographic compositions seemed to reflect the qualities that corporations were trying to promote, while successfully framing out any adverse conditions or effects. Margaret Bourke-White became the best-known of these image-makers, and her name was soon synonymous with an attitude of capitalist expansion, even in the beginning and middle of the Depression. International Paper probably chose her to document their operations because they viewed her as the most effective voice for their message of industrial power.

The venues for the corporate work varied. New photographically illustrated magazines allowed a more public exposure for the photographs commissioned. Most famous among those was *Fortune*, founded by Henry Luce as a sumptuously illustrated business magazine. *Fortune* produced elegantly laid out and beautifully printed photographic essays that usually extolled industry, capitalism, and corporate progress, not only in the United States but in Germany, Russia, and other countries as well. The imaginative sequencing of images and a narrative method that had evolved with the development of picture magazines like *Berliner Illustrierte Zeitung, Münchner Illustrierte Zeitung, Vu, Voilà, Life,* and *Look* allowed new creative possibilities. The European magazines of the late 1920s and their American counterparts of the 1930s pioneered new uses of photographic imagery. Unusually shaped photographs, page layouts highlighting the overlapping, collaged effect of photographs, new graphic design elements being created during these years, and the personalizing effect of the newly developed picture story were all marshaled to increase corporate profits and sell goods.

Corporate books were a familiar external marketing tool as well, although International Paper and Power belonged to a select group of companies who lavished unusually large amounts of care and money on the creation of their promotional books. The role of the book also assumed a particular power in this discourse between the two world wars. Photographs could be printed on luxurious paper and with expensive printing techniques, creating beautiful objects that remained crisp and machine-like in their formal beauty. The sequencing of pictures, their presentation, and the text surrounding the images could add a particular slant to a company's message, encoding a suggestion of progress, stability, growth, or whatever message was part of the corporate plan at the time when the book was produced.

Photographically illustrated corporate books are not a new vehicle for business promotions. Albums of albumen prints accompanied the construction of the railroads in the nineteenth century. They documented the newly aggressive marketing of the French government railroads (in the presentation albums of Edouard-Denis Baldus), and the expansionist progress westward of the American railroad industry (in the boosterist volumes compiled by Andrew Jackson Russell and Alexander Gardner), among many others.

Several exhibitions at the Boston University Art Gallery have explored the intersections between art and technology in the Industrial Age, from the nineteenth century to the twentieth. *From Icon to Irony: German and American Industrial Photographs* explored the intersections of industrial photography in the 1920s and 1980s, and the cross-currents in both decades between two national giants of industry, Germany and the United States.[3] *Painting Machines: Industrial Image and Process in Contemporary Art* investigated sculpture and painting in their interaction with the end of the industrial age, in the 1980s and 1990s.[4] *Mapping the West: Nineteenth-Century American Landscape Photographs from the Boston Public Library* analyzed photographic albums in the context of their roles as boosters for tourism, western development, and railroad expansion.[5] *Power and Paper* continues the dialogue, this time in a study of one photographer, Margaret Bourke-White, and one corporation, International Paper. We hope that this case study will serve as a model for further explorations of the complicated and mutually stimulating cultural collaborations framed in other corporate publications.

1. Andreas Huyssen, *After the Great Divide: Modernism, Mass Culture, Postmodernism* (Bloomington: Indiana University Press, 1986), vii.

2. As late as 1943, Standard Oil hired Roy Stryker, formerly the head of the government's Farm Security Administration photographic project during the 1930s, to amass a photographic archive to advertise the oil company's public face.

3. Kim Sichel, *From Icon to Irony: Germany and American Industrial Photographs*, with additional essays by Judith Bookbinder and John Stomberg (Boston University Art Gallery and University of Washington Press, 1995).

4. Caroline A. Jones, *Painting Machines: Industrial Image and Process in Contemporary Art* (Boston University Art Gallery and University of Washington Press, 1997).

5. Kim Sichel, *Mapping the West: Nineteenth-Century American Landscape Photographs from the Boston Public Library* (Boston University Art Gallery, 1992).

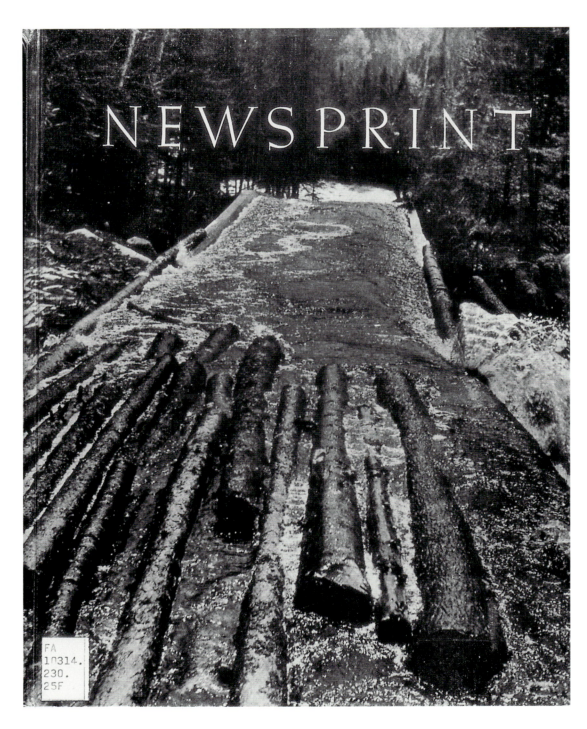

Power and Paper:
Margaret Bourke-White, Modernity, and the Documentary Mode

JOHN R. STOMBERG

MARGARET BOURKE-WHITE'S PHOTOGRAPHY developed through a Darwinian process of elimination whereby only the strong, effective photographs survived the criteria of her various editors to make it to publication. She seldom created work for the calm of a gallery wall, but rather designed her images to withstand the visual cacophony of a magazine. She arranged her subjects in the most compelling compositions possible, always striving for dramatic impact. The photographs in this exhibition demonstrate her continued use of dynamic, persuasive images even as her interest shifted from subjects mechanical in nature to those of human nature, and they illustrate the breadth of photographic practice she could bring to a single, if monumental, commission.

International Paper and Power Company, one of the largest paper producers in the world, commissioned Bourke-White to photograph their newsprint manufacturing operations in Canada in 1937. The company made a variety of papers in the United States but processed most of their newsprint (paper for printing newspapers) in Canada, where most of the world's newsprint was produced.[1] Probably in preparation for their fortieth anniversary the following year, the parent company planned a seventy-two page, hard-bound promotional book to be published under the title *Newsprint: A Book of Pictures Illustrating the Operations in the Manufacture of Paper on Which to Print the World's News*.[2] The book reaffirmed International Paper and Power's commitment to their newsprint operations at a time when their Canadian output levels reached an all-time high. Bourke-White had experience working on corporate publications, but nothing on the scale of this new book. Her prior corporate commissions had usually involved five to ten photographs published in a ten- to twenty-page booklet.[3] Even her own books, hailed for their profuse reproductions, did not match *Newsprint* in terms of how many of her pictures were included; her 1931 *Eyes on Russia* included only forty reproductions and her next book, *You Have Seen Their Faces*, on which she was working when she received the company's offer, would contain sixty-six images when published in the fall of 1937.[4] She heartily accepted International Paper's offer to work on a book that would rely heavily on approximately eighty of her photographs to convey the story.[5] With the exception of a few stock shots and some micro-photographs of wood fiber, the book contained exclusively Bourke-White's photographs, including the covers, which used images of logs rushing down a timber slide (plate 9).[6]

Bourke-White had already photographed International Paper's Canadian newsprint operations in 1930 while on an earlier assignment for Henry Luce's new luxury business magazine, *Fortune*. These photographs appeared in a story about the company.[7] This *Fortune* article, and indeed much about the magazine in the years that Bourke-White worked there full time, provides a great deal of insight into the creation of *Newsprint*.

She even reused a few of her 1930 images for *Newsprint*, but to fulfill the scope of her new commission she had to revisit the area of Quebec where the company's operations were centered. The photographer made her second trip in the spring of 1937. Before *Newsprint* was published, photographs from her Canadian trips also appeared in the 5 July 1937 issue of Luce's newest magazine, *Life,* for which Bourke-White was now working, and again in October of that year in *Fortune*.[8] In each of these four incarnations, *Fortune* in 1930 and 1937, *Life* in 1937 and finally in *Newsprint* in about 1939, her photographs were arranged to suit the differing narrative requisites of their context. In this exhibition we have tried to recreate the narrative as Bourke-White saw it, essentially creating a fifth interpretation, by selecting photographs representative of each phase of the work she produced on this subject.

Over the summer of 1937, Bourke-White used the negatives made on her International Paper trips to create what was her most ambitious—in scale and scope—corporate publication to date. She made hundreds of prints from which the company could make selections for their book, and she used every mode of image-making then in her repertoire, including industrial, documentary, advertising, portraiture, and aerial photography. The work she completed for this commission acts as an encyclopedia of her photographic endeavors. She also showed every stage of newsprint production and the people involved with that production. Many of these images were published in *Newsprint,* but Bourke-White's interests on this assignment went beyond what the company had in mind for their publication. A corporate book's utility lies in its ability to promote the company as exciting, interesting, and a strong investment opportunity. Understandably, Bourke-White sometimes strayed from the direct requisites of her work. For example, while photographing a log drive—the spring effort to move the logs down various waterways to the paper mills—she began creating images of great abstract beauty that offered little information on log transportation (plate 12). Furthermore, while visiting the towns surrounding the mills, she spent time photographing a local church, parishioners, the priest, and even a mass in progress (see plates 28–32). As she worked, she seems to have gone beyond the commission's mandate. The scope of her interest expanded to capture the totality of the newsprint industry—not just the direct manufacture as was typical for a corporate commission, but the greater social ramifications of the mills' presence in people's lives.

The exhibition title has a dual meaning. On one level, it refers directly to the subject of the photographs themselves; they are pictures of paper manufacture and power production at the International Paper and Power Company. But in a less direct way all photography is paper with power; it is the result of adding the perennially mysterious power of an image to a sheet of paper. The subtitle refers to Bourke-White's self-described transformation in the 1930s. She began the decade primarily interested in the amalgam of business, technology, and modernist aesthetics that fall under the rubric of modernity.[9] She joined in the growing chorus of machine-age enthusiasts who believed profoundly in technology's promise for a better future. In May 1930—the very month her first set of International Paper and Power photographs ran in *Fortune*—a Detroit newspaper featured her credo as part of an article they published about her. In it she said:

> I believe . . . that any great art which might be developed in this industrial age will come from industrial subjects, which are so powerful and sincere and close to the heart of life. It seems to me that huge machinery, steel girders, locomotives, etc., are so extremely beautiful because they were never meant to be beautiful. . . . They are powerful because the industrial age which has created them is powerful and art, to be of any importance as a reflection of these times, must hold the germ of that power.[10]

In a 1932 radio broadcast she applauded the new Soviet Union and its citizens because they "were a people who thought about dynamos as beautiful, who loved the rush of molten metal in a steel mill. . . . Who believed as I do that the artist of today will find a real and living beauty in machines because this is a machine age."[11] Many of the images she created for the *Newsprint* assignment, notably plates 21 and 22, glorify the forms and opportunities offered by machines. These are images reflective of her continuing relish for technological society and its promise for a better world.

In an approach still relatively new to her, Bourke-White also made documentary photographs of lumberjacks and millworkers in their camps and homes for *Newsprint* in 1937. On assignment for *Fortune* in 1934 she had witnessed firsthand the human cost of a drought that extended from the Texas Panhandle to the Dakotas. She remembers that:

> This was the beginning of my awareness of people in a human, sympathetic sense as subjects
> for the camera and photographed against a wider canvas than I had perceived before. During
> the rapturous period when I was discovering the beauty of industrial shapes, people were only
> incidental to me, and in retrospect I believe I had not much feeling for them in my earlier
> work. But suddenly it was the people who counted.[12]

Ironically, Bourke-White's new focus paralleled that contained in many machine-age jeremiads sounding an alarm about the negative impact of technology on society.[13] But, as Theodore Brown argues, "Bourke-White's changing attitude was by no means as extreme as [some], since she never renounced her love of technology. Instead, she expanded her vision to include the flesh and blood elements of a troubled world."[14] She continued to be interested in the cultural and aesthetic potential of machines, but broadened her photographic enterprise to take into account their effect on the lives of humans.

In 1937, the year she worked on the *Newsprint* commission, Bourke-White prepared a manuscript for publication in *Nation's Business* magazine. Explaining her changing view of industry and business, she wrote:

> If events of the past few years have shown anything with certainty, it is that industry is not a
> completed science. It has far more to learn about itself than it knows now, however volumi-
> nous the existing knowledge. . . . There was too much emphasis on facts in a given situation, a
> given plant or a given industry, and not enough on their relation to the whole. I think the use
> now being made of photography by businessmen is proof that this attitude has undergone a
> tremendous change, though it still persists in many places. The social point of view is develop-
> ing. Businessmen are asking themselves how their plants fit into the national economic and
> social scheme.[15]

Her text considers the specific uses businessmen have for photography. She wrote, "I happen to know that businessmen with open minds have frequently obtained more value from the prints they didn't publish than from the ones they did."[16] She argued that a "social point of view" was developing in the business world, even if the published record did not yet reflect this development. Written soon after her International Paper commission, it seems entirely plausible that she was referring to her work on *Newsprint*. In fact, many of the prints she prepared for the book were not published. This exhibition reflects the immensity of her vision for *Newsprint*, and includes many of the unpublished photographs.

Bourke-White's merger of her interest in machines and people became the focus of her efforts for *Newsprint*. The rustic nature of the workers' lives could have mitigated against her machine-age optimism, but

she attempted to reconcile the paradox of the two tales within the story of newsprint. At the beginning there are only men with axes. They eat rough camp bread and use horses to haul logs from the forest. At the other end of the story, 250-foot-long Fourdrinier machines convert the "digested" pulp (still 99 percent water) into newsprint used for printing big city newspapers. From the simplicity of felling trees by hand in the forest to the mass production and distribution of a commodity, Bourke-White's story of newsprint reflected the infinitely complex machinations of modern industrial society.

The photographer's first encounter with International Paper's Canadian operations came when she traveled to Eagle Depot in Quebec in January 1930, before the first issue of *Fortune* had been printed.[17] The winter scenes in this exhibition, plates 1–4, and some of the interiors, plates 21–22, resulted from that first trip. *Fortune* sent her to Quebec at the height of their prepublication rush to stockpile stories. She often recalled this trip in the years that followed; it came to symbolize the rigors she was willing to endure to secure her pictures. In one extended description she remembered "taking pictures at twenty-seven below zero in the lumber camps in Canada, when it was so cold my lens froze and I had to prop open my shutters with pencils to make them work."[18] She also described the trip in some detail to Dorothy Sheldon in 1932. Discussing Bourke-White's first year at *Fortune*, Sheldon writes that:

> Her next assignment took her to the North Woods, first to Quebec, then up the Gatineau
> River to the lumber camps, to photograph the making of paper for an article on the
> International Paper Company in *Fortune*. . . . She lived in the lumber camps, traveled on
> snow shoes, and went about dressed in lumberman's clothes: trousers, four pairs of socks,
> soft cowhide shoes, two pairs of mittens and a hood which covered all but her eyes. They
> had to watch each other constantly for signs of freezing. . . . At night the wolves howled out-
> side the camps, but she went to sleep fortified by food worse than any she found later in
> Soviet Russia.[19]

The heroic nature of business was matched by the heroism of her endeavors. She often commented on photography's appropriateness for industrial subjects and on the monumentality of industry, and she clearly saw photography's role in picturing industry in monumental or heroicizing terms as well. She reflected this ideology in her photographs of the lumber and paper operations.

The first of the International Paper images to be published were those made in the winter of 1930; they were carefully arranged in an eight-page article, entitled "Power and Paper," published in *Fortune* that May.[20] *Fortune* structured many of their articles as visual essays, a formula that was taking shape quickly in the early issues—their first copy came out in February 1930.[21] The formula in those days of the magazine's production involved showing a narrative with photographs that represented a body of ideas embraced by *Fortune*. At that point, the magazine practiced a form of less-than-subtle boosterism for American business. Their use of photographic essays, while somewhat rudimentary in their narrative structure, exhibited true finesse in communicating an ideology through their arrangements of imagery.

The organization of the photographs in "Power and Paper" reflects the productive ideology at work at *Fortune*. Rationalization theory lay at the heart of this ideology. In seeking a clear definition of rationalization theory, Robert Brady cites the report of the Committee on Industry of the World Economic Conference (Geneva, 1927), which concluded that rationalization "includes the scientific organization of labor, standardization both of material and of products, simplification of processes and improvements in the system of transport

and marketing."[22] But as rationalization describes a philosophy of process, it could not be photographed itself. In this article, pictures of the wild, raw material becoming increasingly standardized acted as the visual attribute of the theory. The images depict ever greater degrees of refinement as evidence of the process. The photographs begin with images of the great forest (plate 1) and then proceed to show increasing modifications to the trees, showing stacks of regularized logs waiting for transport downriver (plate 2). Finally, we see smaller logs prepared for the chipper. At this point the logs begin to lose individual identity; they appear more as part of a pile than as separate logs. Within the piles irregularity persists, but the logs are clearly at midpoint in their transformation from individual objects to bulk raw material. In the following images the logs appear transformed into piles of chips. The final images show an endless sheet of smooth, even paper. The refinement process is complete (plates 21 and 22). The promise of the forest's raw material has been fully realized by the rationalized process of production—unused resources have been transformed into a valuable commodity.

The replacement-of-nature motif is also brought out in the introductory text of "Power and Paper." First the author, unidentified as were all of Luce's writers for *Fortune*, guides the reader to the exotic locale for the story:

> This is Eagle Depot: a cluster of twenty-four log-walled buildings capping a loaf-shaped hill.
> It is a long way from New York. Take the sleeper for Ottawa. Look at Parliament Hill and the
> Victory Tower. Then look north, up the Gatineau. Through thick forests and deep snow.
> Along the Brule where mighty trees burned and where the wind now whips cruelly through the
> bush. To Eagle Depot, the huts and the hill.[23]

Then the author brings the reader back out of the wilderness of raw materials to the "10,000,000 North American literates" who read newspapers. In five brief paragraphs the writer sums up, and reflects in his prose, the essential character of the Machine Age—"mighty trees" transformed into "sixteen-foot logs." The author guides the reader from the irregular world of nature qualified as "mighty" into the regular world of modern commerce quantified in "sixteen-foot" increments. The irrational chaos of man's dark past has given way to a rational order promising a brighter future.

The look of machine-age art derives from a variety of impulses and turns up in a wide range of topics. In photography the style was a combination of straight photography, abstract principles of design, and a belief in precision, rationalization, functionalism, and standardization that lay behind mass production. Even the photographic production strategies used in Bourke-White's studio, based on an industrial production ethos, provide a machine-age paradigm.[24] So prevalent was the machine-age style that we find it even in instances of nonmechanical topics. In an image of logs, Bourke-White applied these standards to a natural subject and the look of the picture—combined with its context—betrays the machine-age nature of the work (plate 16). This photograph exemplifies an important, though often overlooked, claim by Thorstein Veblen that:

> Wherever manual dexterity, the rule of thumb, and the fortuitous conjunctures of the seasons
> have been supplanted by reasoned procedure on the basis of a systematic knowledge of the
> forces employed, there the mechanical industry is to be found, even in the absence of intricate
> mechanical contrivances. It is a question of the character of the process rather than a question
> of the complexity of the contrivances employed.[25]

The mantra of standardization, rationalization, and functionalism—"the character of the process"—was certainly incorporated in the depiction of industrial subject matter, but these themes also permeate nonindustrial subjects. In plate 16 the individual has been given up to the masses. The identity of the logs has been twice sacrificed: first to make the singular mass of the log pile and second as the logs lost their identity to become an arrangement of abstract forms. In both interpretations, this image of logs provides clear articulation of Veblen's idea that "the scope of the process is larger than the machine."[26]

Veblen's discussion of the nature of "mechanical industry" heralded the acceleration of concern for industry's role in American culture and society. Writing in 1904,[27] he spoke in advance of most of his contemporaries on a subject that would become commonplace to the point of tedium over the next three decades.[28] Writing at almost the same time, 1906, though receiving nothing like Veblen's stature during his lifetime, Gerald Stanley Lee also wrote on the subject. In his *The Voice of the Machines: An Introduction to the Twentieth Century,* Lee showered praise on industry as a great potential source of profound new artistic material. Unlike Veblen, Lee embraced industry and machines with hyperbolic fervor. He wrote:

> If there cannot be poetry in machinery—that is if there is no beautiful and glorious interpreta-
> tion of machinery for our modern life—there cannot be poetry in anything in modern life. . . .
> In taking the stand that there is poetry in machinery, that inspiring ideas and emotions can
> be and will be connected with machinery, we are taking a stand for the continued existence
> of modern religion—(in all reverence) the God-machine; for modern education—the man-
> machine; for modern government—the crowd-machine; for modern art—the machine in
> which the crowd lives.[29]

But Lee's approbation had little company until just before the First World War. Though the interest in the cultural ramifications of the Machine Age continued to grow throughout the first decade, not until the early years of the second decade did the cult of the machine begin to mature.[30]

The rapid maturation of the machine-age style in America began in New York with European artists. First with Marcel Duchamp, Francis Picabia, and the group associated with Alfred Stieglitz's *Camera Work.* This group included Paul Haviland, who provided the guiding spirit for the dada journal *291.* Another group, associated with a more austere machine style, was centered on Walter Arensberg and included Charles Sheeler and Morton Schamberg—precursors for the machine-based style of Bourke-White.[31] These two groups certainly exchanged ideas, but rifts between them regarding the role of art in society would emerge after the war and make the differentiation clearer in hindsight.

The dada group of Duchamp insulated themselves from the world in a way that Sheeler, and later Bourke-White, did not. The key issue became commercial work, and it was this issue that eventually divided the group. Duchamp and Picabia worked only in the realm of art production for cognoscenti. As a result, the work they produced had great impact, but mostly with their colleagues. Their world was the art world, and the changes they wrought and influences they exerted were felt primarily within the art community.[32] Sheeler transformed Duchamp's witty, sexy mechanomorphism into a machine-based aesthetic that had a broad appeal, and like Bourke-White, created images that reflected a mainstream interest in the productive capability of machines. By the time Bourke-White went to Quebec for International Paper the first time, she had a clearly established, technology-inspired style. She sought out images that answered her call for an art reflective of the world in which she lived, the machine-age world. Most common among her subjects were machines, their products, and industrial landscapes.[33]

When she returned to the region seven years later her interests had broadened considerably, though in a trajectory established before she became famous. Bourke-White had developed her style as an architectural photographer in Cleveland in the late 1920s.[34] Inherent in her early architectural photography was an interest in the buildings and houses as objects—her photography was not concerned with their inhabitants. In the fall of 1927, she began creating monumental images of industrial sites on her own time. She managed to sell many of her industrial images to the public relations manager at a local bank for use on the cover of the bank's monthly magazine *Trade Winds*.[35] These industrial images marked a clear departure from her earlier subjects and signaled her turn to the imagery that would establish her career, but they shared the unpopulated feel of her architectural work. They focus on the industrial subjects without reference to their human context.

In the mid-1930s she consciously began to factor in the impact of her industrial subjects on the people who came into contact with them. This expansion of her interests coincided with Luce's development and eventual publication of a new pictorial magazine, *Life,* in 1936. In the pages of *Life,* the American photo-essay reached maturity and the human element usually dominated the stories. Wilson Hicks, a longtime picture editor at the magazine, wrote that the editors at *Life* discovered that images could be "manipulated" with the same proficiency as text and that this was the essence of photojournalism.[36] *Life* emphasized the reconstruction of a story through pictures; the captioning and articles, while important, played subsidiary roles. The pictures in the magazine became responsible for carrying the story.

While negotiating with International Paper for the *Newsprint* commission, Bourke-White managed to put W. A. Von Hagen of the company's New York sales department in touch with Daniel Longwell, her editor at *Life*.[37] Longwell acquired a selection of the photographs commissioned by International Paper for the 5 July 1937 issue of *Life*.[38] Having the pictures run in America's hottest new picture magazine provided the company with great promotional exposure. The *Life* story provided a visual narrative of newsprint manufacture. It started, as *Newsprint* would, with a dramatic, full-page image of a lumberman running across a log jam—the same man as in plate 8. The article continues with several further images of logging (including plate 11 and an aerial view of log booms being towed across water similar to plate 12) before turning to a series of images specific to the paper mills. On the penultimate page of the essay, *Life* printed eight numbered images on one page (including plates 18 and 22), as though publishing a manual for paper production. The last page contains an image of men attending to the finished paper in the mill and one of the wrapped rolls of newsprint being loaded onto a ship, the end of the story for *Life*. International Paper appears to have allowed *Life* access to most of the material Bourke-White produced on her 1937 trip, but the magazine used few of the images that actually ended up in *Newsprint*.

Fortune also used Bourke-White's new International Paper photographs in October 1937, in conjunction with a general article on paper production.[39] Unlike the 1930 story, which focused on one corporation, this was an industry story describing the nature of an entire field, in this case the production of paper. The lead image uses two different Bourke-White photographs from her trip to the Gatineau region. The background image consists entirely of logs in a random pattern; the inset, like plate 16, illustrates a man attending to a holding pile of lumber. The other images in the story were neither Bourke-White's nor of International Paper. It is not clear if *Fortune* procured the Bourke-White images from Von Hagen or simply borrowed them from *Life*, their sister publication. In either case, the images did not play a major role in the essay.[40]

Von Hagen appears to have first contacted Bourke-White early in February 1937 to discuss the *Newsprint* commission.[41] They negotiated the terms of their agreement while Bourke-White traveled through

the southern United States working on further images for *You Have Seen Their Faces*. After a few false starts, she went to Canada at the end of May 1937.[42] Just before leaving she wrote to her uncle Lazar (Lazarus White) that:

> This Canadian trip is an independent job taken apart from my work for *Life*. I'm taking a group of three mills and exterior logging shots to illustrate a book on paper making and I'm going up in time to catch a log jam, some of which I hope to get from an airplane. Lumber camps, as you know, are not new to me but I'm very fond of them so I'll enjoy the job.[43]

The commission to which she referred was independent from her work at *Life* in more than contractual terms. It brought her back to the type of work she had regularly created for *Fortune*. Indeed, *Newsprint* can be seen as an elaborate corporation story—a regular feature of *Fortune* in which one company received in-depth coverage. When she received their commission, she was on familiar ground. They were approaching their fortieth anniversary, and after a tumultuous decade of expansion they wanted a publication that would reestablish them as a company focused on the manufacture of paper.

International Paper Company originally formed through the merger of sixteen paper and pulp companies in New York, New England, and eastern Canada on 31 January 1898.[44] They immediately became the largest manufacturer of paper in the world. During their first three years they continued to acquire smaller manufacturing companies, expanding their interests as far west as Michigan and further north into Canada. From the start, the company's strength lay in its newsprint manufacture—it produced somewhere between 66 and 75 percent of the total newsprint consumed in the United States at the turn of the century.[45] Under its first three presidents, the company followed a policy of consolidating the disparate companies that made up the parent company, a policy that lasted up to World War I.

Though their output remained basically level until the war, International Paper's share of the newsprint market dropped radically by 1913—to 26 percent—due to a rapidly expanding demand for their product. They continued to have mammoth production capabilities, but with demand rising as fast as it was, competition developed to fill the gap between their level of supply and the increased demand. Beginning with Philip T. Dodge, company president from 1913 to 1924, International Paper reversed its decades of consolidation with aggressive expansion and diversification. In 1919 they began moving their newsprint operations to Canada, where they held vast timber leases and where, it was becoming obvious, newsprint could be manufactured at a considerably lower cost than in the United States for a number of reasons.[46] First, Canadian provinces began prohibiting the export of pulpwood to the United States, forcing manufacturers to set up operations within the provincial borders.[47] Further, in 1911 the United States began allowing finished Canadian newsprint to be imported duty-free.[48] A final serious factor in the move was that sources of pulpwood in the northern United States had been decreasing rapidly in the preceding decades.[49] The company might have moved into Canada sooner, but with its enormous fleet of aging mills in the United States, most of the funds allocated to physical plant annually went into maintenance rather than new construction. The change came with the post World War I surge in sales that gave the company the funds necessary to start the move.[50]

International Paper's growth during this period leading up to the *Newsprint* commission—1913–1936— was largely fueled by its production of newsprint, which paralleled the explosion in demand for newspapers in the United States. Frank Luther Mott, the noted author on American magazine and newspaper history,

attributes the growth in newspaper circulation to two factors. First, newspapers at the turn of the century began aggressively marketing their product to their audiences, which led to skyrocketing demand; then, with the development of high volume/high speed presses after 1895, they were able to meet that demand with a greatly increased supply of newspapers.[51] An article in *Fortune* magazine in 1930 profiling International Paper makes clear the link between the demand for newspapers and International's growth in the 1920s. "In 1900 it was possible to print all the newspapers of the country on about 750,000 tons of paper. By 1920 this had increased to nearly 1,250,000 . . . by 1928 to more than 3,500,000."[52] A further factor effecting the demand for newsprint was the rapidly increasing space in each newspaper devoted to advertising.[53] Even with editorial content holding at steady amounts, newspapers were increasing their physical size to accommodate advertising, an effect especially noticeable during the boom years of print advertising in the mid-1920s. Though International Paper no longer enjoyed a majority of the market, they remained larger than their two closest competitors combined and, to the chagrin of their competitors, their annual price announcement usually established the norm for that year.[54]

During the 1920s International Paper also expanded into the southern United States, further diversifying their business by buying and opening kraft paper factories.[55] The greatly increased size of the company prompted the author of the *Fortune* article to refer to the "empire of International Paper Co.," which he put into perspective for his readers. "Beside its [International's] 35,400 square miles, the plantations of Ford in South America, Firestone in Liberia, [and the] United Fruit Co. in the Caribbean seem insignificant. It is larger than eleven of the United States and larger than sixteen of the independent nations of the world."[56] The author details annual mill production and offers comparisons for clarification. For example, "from the Gatineau mill come 600 tons a day [of newsprint], the distillate of 8,000 spruce trees, enough to make 3,400,000 copies of the New York *World*." Significantly for Bourke-White's commission, industry-wide newsprint production in Canada and the United States set a record in 1937 that would hold for another decade.[57]

International Paper had long used well-illustrated publications as instruments of public relations. In 1901, three years after its founding, the company published a lavishly illustrated, 108-page book. Simply titled *International Paper Company*, this book signaled the completion of the original formation of the company—the first twenty companies merged into one.[58] After a brief history of paper production and the company, lists of corporate officers, stock distributions, and an abbreviated balance sheet, the text gives way to over ninety pages of illustrations. This first book established the norm that further International Paper publications would follow—most notably *Newsprint*. The first scene is of winter logging, followed by pictures of spring log runs. The progress of the logs is followed step by step throughout the process of converting the logs into chips, chips into pulp, pulp into paper, and paper into finished product. This section is followed by photographs of all the company's mills—a veritable inventory of nineteenth-century industrial building design set in bucolic rural landscapes. The girth of the book matched that of the company, overtly stressing the might of the new company to potential investors.

On their twenty-fifth anniversary, International Paper again produced a promotional book.[59] This publication, only forty-two pages, relied much more heavily on text than had its predecessor. The author, W. E. Haskell, described the process of paper manufacture in great detail. His text was accompanied by carefully engraved illustrations of the various aspects of creating pulp from wood chips and paper from pulp. Engravings of the company's mills also punctuate the text at various points, though they do not so much illustrate the text

Gelatin silver print
1937
9 ³/₄ x 13 ¹/₂ inches

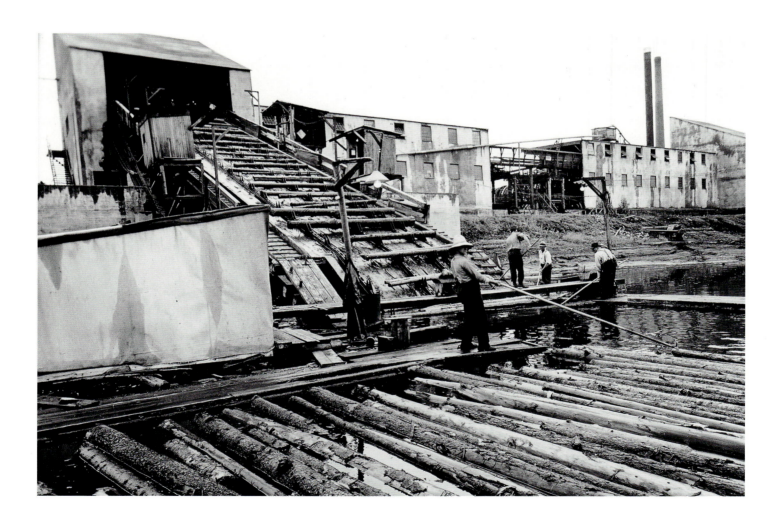

as offer beautiful, visual digressions. The largest illustration, a two-page spread, was devoted to the new mill at Three Rivers in Quebec, testimony to the growing importance to the company of the Canadian operations.

By 1927 the Canadian operations had become so important to the company that they dominated a separate, illustrated publication "designed to give an idea of the scope, size, and diversity of the operations of the Company."[60] Fully three-quarters of the later booklet, *International Paper Company*, concerns the company's Canadian operations. Printed in June 1927, the booklet apparently had the desired effect. On 15 July 1927 the investment firm of Schirmer, Atherton, and Company produced an advisory to their clients that built on the information just released by International Paper. Their conclusion:

> International Paper is obviously passing through a highly formative transition period. The bulk of its paper business is being transferred from scattered, high-cost production units in the United States, to concentrated low-cost units in Canada possessing the benefits of cheap power and enormous timber land reserves. Diversification of risk is being attained through expansion in the kraft paper field and the development of water powers and other natural resources.... While the transitory period may last from three to five years, it is our belief that the net earnings of the company will rise steadily for several years as new paper plants come into full and more efficient production.... International Paper common appears to be an excellent purchase.[61]

By the time Bourke-White toured the Canadian operations for the first time, in January 1930, they had become an enormous and vital component of an already mighty corporation.

Newsprint followed the structure of its corporate predecessors, as well as of the 1930 story in *Fortune*. The story of newsprint manufacture began in the forest in winter and progressed through the manufacturing process. In plate 1, which appeared in the original article, we see snowshoe tracks leading into a seemingly infinite forest stretching as far as the eye can see. *Newsprint* used a somewhat similar winter landscape to begin its section on winter logging. Bourke-White's careful cropping emphasizes the sense of an infinite landscape. Alan Wallach has long argued that this type of view in nineteenth-century American landscape paintings established the art patron in an ownership role, and it seems to have had a similar use in this case.[62] The panoramic gaze of Bourke-White's point of view subtly claims the land as belonging to the viewer. The image establishes International Paper's domain; it is a case of the landscape as inventory.[63]

Plate 2, used in *Newsprint* and similar to one published in *Fortune*, shows teams of men at work stacking logs. Horse-drawn sleighs could carry these mammoth loads out of the forest due to the decreased friction offered by the snow. In winter the lumbermen store logs beside the frozen waterways which, in the spring after the thaw, will carry the lumber to the waiting mills below. The stacks of logs represent the first step in the process of taming the wilderness. The lumbermen work to replace the seemingly random disorder of the forest with the rational order of wood as a commodity. At this stage the trees begin to lose their individual identities as trees and become standardized piles of lumber.

Plate 2 also reminds us of Bourke-White's working methods. She used long exposures to achieve a satisfactory depth of field. This required cooperation from her subjects, who in this photograph appear as frozen as the lake on which they work. Each man has been carefully arranged and stands still for her in a variety of poses. This image also follows the primary lessons of abstract design that Bourke-White learned while studying at Columbia University. Her teacher, Arthur Wesley Dow, instructed his students to view their work as a

composition of shapes, rather than as subjects, and to arrange the shapes in dynamic configurations.[64] In plate 2 we can see that Bourke-White set up her view so that the whole is divided in half laterally and the lower half is divided diagonally, giving her composition exactly the dynamism Dow had promised would result from thinking of the subjects as abstract forms. Bourke-White did not endeavor to disguise the fact that she was creating a composed photograph. Her presence as the creator is felt in the composition, the rigidity of her subjects and even by her own shadow appearing on the bottom left of the photograph. She made no pretense at invisibility and no secret of her participation in the construction of these images.

Bourke-White created a variety of portraits of the lumbermen during her 1930 trip. *Fortune* chose a full-length view of a man with his saw draped over his shoulder. International Paper used the close-up portrait of the same man in plate 3 for *Newsprint*. For this portrait, Bourke-White used an excessively shallow depth of field; only the flat plane of his face appears in focus. The photographer chose to position her camera below her subject's head and to move in until the three extremities of his hat extend just beyond the frame, allowing him to seem too large to be contained within the image. The combination of the low angle and allowing him to fill the frame monumentalizes her subject. The man's knowing half-grin seems aware of the setup and suggests a level of collusion—does he know that he is the hero of Bourke-White's machine-age drama? He harvests the wild potential of the forest to be utilized in perpetuating an urban culture of consumption in which she had great faith.[65]

Plates 5–14 represent a particular time in the calendar of paper manufacture; they follow the action of the spring log drives. These plates survey the activity from life in the camps to tethered log rafts being brought to the mills. In plate 5 Bourke-White neatly arranged the men inhabiting a lumber camp.[66] *Newsprint* used another photograph from the same session—an image of the men sitting around a woodstove sharing a moment of convivial bonhomie. In plate 5 they sit awkwardly perched on a narrow wooden bench, looking comfortable neither with their seating arrangements nor with being photographed. The few attempts at seemingly random elements betray patently obvious compositional conceits. The two men on the top bunk do not line up with the main head-row below, but they top a compositional pyramid, strengthening the design—as does the inset head at the right. The still life in plate 6 also appears plausible, but once again she used a strong pyramidal composition to anchor the design. Each object plays a role in the design as well as in describing life in the lumber camps as rustic, but appealing. The tin cups and the sooty pot with the ill-fitting lid work in unison with the bread to illustrate camp life, and she laid it all out on top of birch bark, a likely, if overly obvious, attribute of a logging camp. With this image, Bourke-White was selling her viewers on the wholesome rectitude of logging practices.

After the relative calm of the camps, the work of moving logs downriver provided Bourke-White with ample opportunity to depict the lively nature of the lumbermen's work.[67] We witness another of her methodological transformations as she adapts her approach to the new situation. In plate 8 she manages to catch her subject in what Henri Cartier-Bresson would later describe, though already practiced, as the "decisive moment." He said, "inside movement there is one moment at which the elements in motion are in balance. Photography must seize upon this moment and hold immobile the equilibrium of it."[68] The logger was caught in the exact moment between one position and the next. His left foot just makes contact with the log, but has yet to submerge it at all. His right foot has left its perch still submerged, just beginning to float back to the surface. The man seems to float in mid-air, water dripping from his right boot. His staff lines up parallel over the log on which he is landing. Bourke-White captured the particular moment when all of these various

attributes coalesced into a strong visual equilibrium. She moved from the agrarian impulse of the still life to the hunter-gatherer instincts needed for the logging scenes.

Life published plate 7 and *Newsprint* used a horizontal variant of the same scene—both used the pedagogical value of the image. In it, the lumberman displays the two definitive tools of his trade. He obligingly holds his right foot up as though about to step off the log. In this manner, he exposes the cleats on his boot that allow him greater traction. He also displays the end of the grappling hook specific to logging—a peavey—with which he can push or pry logs apart when jammed. Bourke-White uses the same approach to plate 7 that she usually reserves for machines. In this logging scene, as in plate 22, she moves her camera in close to better detail the simple massing of her subjects. While in plate 22 this approach reveals the precise geometry of the machine, in plate 7 it elaborates the simple technology of logging. With this composition, Bourke-White imposes order on the chaos of the natural world. Only the water remains wild, but by using an exposure considerably slower than that used for plate 8, she renders the water insignificant and immaterial —bowing its will to the might of the peavey hook.

Plates 9 and 10 show a timber slide, an elevated canal used to transport logs rapidly out of the forest. Plate 9 appears on the back cover of *Newsprint* and a view from the same position, but taken at a different moment, appears as the front cover. This image seems a clear choice for the company; it depicts the steady, reliable march of logs with the concomitant promise of steady, reliable production. Plate 10 exemplifies Bourke-White exploring the formal possibilities of a commission to a point where her photography no longer proved useful to her client. Her choice of angle sacrifices clarity in exchange for compositional interest. It shows the side of the same timber slide, but her attention has shifted to the patterns the water makes as it escapes from the canal. Not surprisingly, none of the images taken from this angle were used by the company.

The logging images in *Newsprint* tended toward heroic scenes that romanticized the theme of man against nature. Bourke-White found compositions reminiscent of eighteenth- and nineteenth-century romantic paintings. In *Newsprint* some of these were included as insets against a background image of logs on the river and a few others were printed across a full page. They express the vision of logging that the company wished to portray. Though not included in *Newsprint*, plate 11 fairly represents this group of photographs. On a basic level it provides technical information. We can see the terminus of the timber slide and how the lumbermen deal with a bona fide logjam. While only three men are visible, three more work at the jam from beyond the frame—the handles of their peaveys can be seen on the right. It took cooperative effort to keep the logs flowing downstream smoothly. Bourke-White used a faster shutter speed in this photograph to capture the water's power. To soften the rapids into a cottony flow would diminish the heroism of the lumbermen's acts by diminishing the power of their adversary. She also emphasized the force with which the logs, propelled by the timberslide's combination of water and gravity, entered the creek and became ensnared in massive piles. Life and death seem to hang in the balance. The danger of the lumbermen's task surfaces in the mysterious tension holding the pile together. The lumberman with his peavey becomes Captain Ahab in Melville's great novel and Watson's shipmate with his harpoon in Copley's painting.[69] Both figures carried destiny in their raised harpoons, a dramatic tension Bourke-White applies to her image of the lumberman battling the logjam.

Once the logs reached large bodies of relatively slow-moving water, they were sorted by size and tethered together with immense booms to be towed downriver.[70] The log booms swelled across the water in amorphous configurations that appeared oddly organic, especially from the air. In plates 12–14 Bourke-White

aestheticizes what might otherwise be considered a defacement of the landscape or even an environmental hazard. Far from any menace that these vast flotillas might have posed, she saw in them forms unavailable to the land bound. In plate 12 the logs complement the vaguely zoomorphic outline of the boom by taking on the tufted appearance of fur; the sun highlights areas differently based on how far they rise out of the water. And in plate 13 the sunlight reflects off the ripples of the lake, creating a variegated pattern across the surface of the water. International Paper used both of these images as a part of a selection of aerial photographs that acted as the pastoral transition from the forest to the mills in *Newsprint*.

Bourke-White had a special passion for aerial photography; she commented in a draft of her autobiography that "airplanes to me were always a religion."[71] She included aerial photographs in many of her projects after spending a month perfecting the technique while working for Trans World Airlines in 1934. She maintained her enthusiasm for the practice throughout her career. Recalling her excitement that first time she worked from the air for the airlines, she described feeling cut off from the world:

> . . . as though we [she and the pilot] were on the planet Mars. This was an important beginning in a type of work which I am still [c. 1955] very much interested in. Now . . . there is a very great opportunity to show the world in a new way. There can be a real partnership between the camera and the aircraft as though, it seems to me, a new instrument was created.[72]

Her airborne views down onto the earth emblematized technological achievement. Regardless of the subject, one aspect of her aerial photography was her continuing enthusiasm for the feats of engineering that had profoundly changed her views of the world, figuratively and now literally. For Bourke-White, aerial photography became associated with the historical period in which she lived, the Machine Age.

In fact aerial photography had been utilized sporadically in the nineteenth century—most notably by the Parisian photographer Nadar who floated above the city in a hot air balloon. The more practical applications of aerial perspectives were not further realized until World War I, when photographers like Edward Steichen were enlisted to create topographical views of otherwise inaccessible areas.[73] And *Fortune* often published the work of an ex-RAF pilot, Captain Alfred Buckham, who made his post-war career as an airborne photographer. In their third issue they ran a portfolio of his photographs along with a brief biography and introduction—the only photographer other than Bourke-White to receive such treatment.[74] The editors sang the praises of Buckham's work and of aerial photography in general:

> As immobilized fragments of the panorama which is spread out before the aviator, these photographs are without equal, artistic or technical. They suggest that the photographer and the artist who work, earth-bound, on the world's surface, have barely begun to record its line, its color, and its variety.[75]

The unqualified endorsement her editors gave to aerial photography in 1930, and the star treatment that they lavished on the photographer, makes the lag time before Bourke-White pursued the technique rather puzzling. Once she acquired the skills needed, photographs taken from the air became part of the package she offered to perspective clients—it was a format with particularly attractive advantages for many of her commercial clients.

Aerial photography offered very practical visual solutions to descriptive problems. International Paper's holdings in Canada were vast on a scale only discernible from the air. In the area of the Gatineau River alone, where Bourke-White visited, they had operations extending from Trois Rivières in the east, southwest along the St. Lawrence and Ottawa Rivers to Ottawa, and northwest to Témiscaming; their lumber leases extended

throughout this area and far above it into northern Quebec.[76] Since its founding the company had held timber leases in Canada, and they continued to acquire further leases through the early decades of this century as a hedge against the dwindling timber resources in the United States. In 1919 they opened their first Canadian mill at Trois Rivières, which they hailed as embodying "the latest and best in scientific construction and equipment."[77] Even so, in 1924 the new mill represented little more than an announcement of yet another new plant for the company. But they followed the construction of Trois Rivières with the Gatineau mill in 1925, located near the terminus of the Gatineau River on the Ottawa River and then the mill at Dalhousie, New Brunswick, which opened in 1929.[78] These mills were sited downriver from the land where the company held timber leases.

In Bourke-White's aerial photographs we get a sense of the enormity of the company's operations. Plate 14, for example, suggests the complexity and interconnectedness of International Paper's business. (*Newsprint* printed a similar view of a different dam, but one that offered the same type of information.) Dams served multiple purposes for the company. First they created a holding area where vast amounts of lumber could be stored. They also facilitated better control of the pace at which the lumber flowed downriver. We can see that the boom narrows as it approaches the lateral midpoint of the dam. There a specially designed spillway allows a constant, even flow of logs to slip through the dam, enabling the paper end of the business to control the flow of raw materials into their mills downriver. Closing off the flow of logs would also allow logjams to be cleared up downriver before becoming overrun. Dams also provided hydroelectric power, which paper companies needed in excess. The dam became an integral part of the paper business, especially for International Paper with its significant power holdings.

Under Arthur Graustein, the company's president from 1924 to 1936, International Paper entered the power business. In light of this expansion, Graustein established a new parent company in 1928, International Paper and Power Company. In early 1929 the company announced that they had purchased 82 percent of the common stock of New England Power Association, an acquisition on a monumental scale typical for the company. This was the culmination of developments initiated in 1920 with the building of a hydroelectric plant at Sherman Island on the Hudson River in New York.[79] By the time they bought New England Power, International Paper had also been operating the small hydroelectric plant near their Kipawa facility at Témiscaming and had three more under construction along the Gatineau River. When Bourke-White visited the region, the Gatineau Power Company (a wholly owned subsidiary of the parent company) was one of the largest in North America in terms of power output.[80]

International Paper, as the 1930 *Fortune* article points out, based the merger of power and paper on simple economics. "Paper needs power. Power is most economically generated in huge quantities. Other industries need power. Let paper, therefore, make power, to use and to sell."[81] The Gatineau mill necessitated the development of the three power plants on the river, but the company designed them to have plenty of excess capacity, which it sold under contract to other power companies and to other end users.[82] The river, like the forest, was seen as an unutilized resource. By damming the river at multiple locations, the company proudly noted, "it will be possible to utilize to the best advantage the total fall in the river for a distance of sixty-two miles from its mouth and to develop at least two-thirds of the available power in the whole river."[83] Through the company's power acquisitions, International Paper further rationalized their production.

The look of electricity had its own iconography and Bourke-White knew how to evoke its core significance: unlimited power. Unlike coal or oil, hydroelectric power held infinite promise. In her photographs of

the electrical works, plates 25 and 26, she emphasizes that promise by searching out seemingly boundless formal arrangements—such as the rows of switches in the electric control room (plate 25). In plate 26 she returned to the rows of generators that had become one of her signature images. She had pictured rows like this in multiple trips to the Niagara Hudson hydroelectric facilities for an article in *Fortune* in the early 1930s. Images like plate 26, "The March of the Dynamos" as she titled one variant for exhibition, evoke the infinite nature of hydroelectric power. Their subject also reflects the growing popularity of Henry Adams's idea that the fecund power of the Virgin had been replaced by the immense creative power of the dynamo.[84] Published publicly in 1918, Adams's essay "The Dynamo and the Virgin" was widely read in literary circles in the 1920s and 1930s. In fact, Bourke-White placed his book on the top of her list when asked by the *Boston Evening Transcript* to send them "the names of the *five* books published since 1900 . . . which have most strongly affected your ideas."[85] The simplified forms of plate 26, coupled with its established pattern for Bourke-White, suggests it as an icon representing a belief in modernity.

Both of these images—plate 25 and 26—detail a critical element in the cycle of paper production at International Paper and Power Company and represent the thematic heart of machine-age progress; they suggest the very tangible changes technology could bring to people's lives. Electrification held great resonance in the Machine Age. Stuart Chase, whose 1929 *Men and Machines* provided some of the clearest thinking on the Machine Age, contributed an article on electric power to *Fortune* in 1933. Chase concludes his article with the following appraisal:

> In its full development, electricity can yoke a whole continental economy into something like one unified machine, one organic whole. The parts may be small, flexible, located where you please, but with their central station connections, electricity can give us universally high standards of living, new and amusing kinds of jobs, leisure, freedom, an end to drudgery, congestion, noise, smoke and filth. It can overcome most of the objections and problems of a steam-engine civilization. It can bring back many of the mourned virtues of the handicraft age without the human toil and the curse of impending scarcity which marked that age.[86]

And in a rare editorial comment following Chase's article, *Fortune* opined that, "Nothing on the contemporary horizon is more interesting than the beginnings of a widely held belief that the very industrial phenomena which have given most concern to the reactionaries and most comfort to the prophets of woe are actually the harbingers of a very real and very realizable human hope."[87] The editors shared Chase's optimism in the possibilities offered by electrification. They had been returning to the subject since their 1930 article on International Paper and Power, where the benefits of electrification in the company's overall strategy of rationalization were made clear.

After the departure of Graustein in 1936, the company entered into a new era in their development—an era made necessary by the Depression. The lucrative kraft paper businesses of the South had helped to sustain the company through the bleakest years of the Depression. From that example the new president, Richard J. Cullen, himself responsible for the rapid development of the kraft paper divisions, began to scale back International Paper's enterprises to only those with the greatest capacity for profit. They moved further into conversion products, like the pulp used in the manufacture of rayon, and streamlined their operations. Graustein's brilliance for finance had turned International Paper into a labyrinthian complex of holding companies with a wide diversity of products. The board of directors gave Cullen a different mandate: to redouble

the company's focus on paper.[88] The power divisions produced cash flow, critical during the early years of the Depression when demand for paper plummeted, but failed to generate substantial profits. The company decided to divest their ownership in utilities in 1941, at which point their name reverted to International Paper Company as it is still known today.[89] But in 1937 hydroelectric power remained a part of the company, though it certainly no longer had the importance it held a decade earlier. The configuration of *Newsprint* is testimony to power's falling stock in the company. The book gives few pages to the subject, while focusing in-depth attention on actual paper manufacture—Cullen's specialty.

Plates 15–24 and 27 chronicle the narrative of paper production, the dominant subject in *Newsprint*, from the stacking of lumber at the mills to the loading of ships with the finished product. A slight variation of plate 16 appeared in *Newsprint*. This picture shows a man in a tower hosing the log pile with water so as to avoid spontaneous combustion. The danger of forest fires posed the dominant threat to the industry, but fires in the storage piles were cause for serious worry as well; the piles were kept perpetually wet. Plate 15 also appeared in *Newsprint,* along with a group of images of these log piles. Paper mills could not access fresh lumber in the winter months and had to stockpile enough logs over the spring and summer to ensure that production at the mills could continue all year. These piles were constructed by creating a circular log wall to retain the massive pile created within—as the inside pile grew, so too did the retaining wall. In plate 15 we see a fairly mature pile; the man's scale testifies to the enormity of the wooden mountain. He climbs steps made of logs left extended beyond the wall in a spiral up the outside of the pile—to give the workers access to the top.

The logs lose their identity definitively between plates 17 and 19. In plate 17 huge saw blades rip through a never-ending stream of lumber, reducing all to four-foot lengths. Thematically, this image returns to the first *Fortune* article where nature's might is replaced by man's through the extension of his powers by virtue of his mechanical tools. Here the soft vulnerability of the tree flesh offers no resistance to the might of the spinning blade. After their session with the saw, the logs are sent to chippers, which reduce them to the flow we see in plate 18. In this latter photograph Bourke-White managed to provide detailed information about the chips—clear in the foreground—while alluding again to the notion of infinite supply and its promise. The storage facility for the chips provided her with the visual contrast between man-made and natural—geometric and organic—to which she often returned. The regular pace and careful angularity of the steel I-beams emphasizes the irrational, haphazard quality of the chip piles—sure candidates for the rationalized unifying processes in their immediate future.

Plates 21 and 22—the result of Bourke-White's 1930 trip—detail the drying process in which the material that starts at one end of the Fourdrinier machine as pulp finishes as a sheet of paper. In plate 21 the still-wet paper supported by a wire mesh speeds across rollers. This particular photograph was cropped for *Fortune*—though it was not published. *Fortune* often used extreme cropping to add to the dynamism of their pages. Plate 21 exemplifies a print fully prepared for publication; it has a one-eighth inch black border drawn around it to allow a margin of error in the printing registration. A variant of plate 22 appeared in *Newsprint* and another in the 1930 *Fortune* article. In the even geometry of the Fourdrinier's rollers, Bourke-White found fertile ground for her machine-age enthusiasm. These two plates are typical inclusions for *Fortune* and *Newsprint;* though close-up, abstract compositions never dominated the story, they were accents establishing a note of machine-age decor.

Both publications placed the heaviest burden on images like plate 20. In this photograph we see the workers starting up a new roll of paper. In addition to adding practical information to the story, images of men and machines together dispute the view of the machine-age jeremiads claiming that men would be

replaced by machines. In 1921 R. Austin Freeman was already warning that the machine would ruin the tradition and pride associated with hand-crafted manufacture. He wrote, "It is at once evident that the machine worker is not entitled to the same position as the craftsman. He is not a creator. He is not even a producer in any real sense. He is merely an accessory unit in a complex producing mechanism."[90] Plate 20, like all the other images showing men engaged in machine production, argues tacitly against technological unemployment by demonstrating the continued need for the interaction between man and machine. *Newsprint* included many images of the workers responsible for keeping the machines in action. As a corporate publication, it is indeed notable for a conspicuous lack of management portraits. Rather, the human element is demonstrated by the presence of the lumberjacks in the logging scenes mentioned above and by the workers streaming out of the mill in plate 27. Though for the latter print, shot from a slightly different angle than the one used in *Newsprint*, Bourke-White clearly staged an event; its inclusion stands as testimony to the company's desire to show the value they placed in their workforce. They were not the invisible, insignificant accessories that Freeman described, but rather key components in the complex story of newsprint manufacture.

For the last chapter in the narrative sequence of newsprint production, Bourke-White traveled to Dalhousie, New Brunswick.[91] There she photographed the finished rolls of newsprint being loaded onto ships for transport to markets most likely in the United States.[92] In plate 24 Bourke-White includes the man directing the hoisted rolls of paper. He appears in control despite being lost in the maze of the ship's rigging. The man uses technology to lighten his burden, but is not replaced by it, a further indictment against those who preached that unemployment would result from the expanded use of technology.

In the broader view offered by plate 23 we see that many men were involved with this operation. This photograph summarizes many of the themes that Bourke-White targeted on her 1937 trip; it also relates proportionately to the subjects she covered. In the foreground we see the business of paper being carried out, the main thrust of her commission. Men load seemingly endless rolls of newsprint onto the ship. We can make out the International Paper and Power Company trademark—the tall pine with the waterfall in the background—on each roll.[93] The modern ship and the seaplane indicate the contemporary nature of the business and form the majority of the photograph. In the distance we see the metaphorical and literal background to the International Paper and Power story: suggestions of how those carrying out the business of paper manufacture lived. The cathedral on the hill affirms the importance of religion to those inhabiting the houses below. Plate 23 did not survive the editor's bench at *Newsprint*. It contained too much information superfluous to paper manufacture to be included in the publication, but Bourke-White clearly found the background elements worthy of consideration and created a whole group of photographs that related to this theme of the background—none of which were published. This difference—essentially what did *not* get published—offers an informative glimpse into Bourke-White's changing point of view just at the point where it began to diverge demonstrably from the corporate boosterism that had engaged her for almost a decade.

As previously mentioned, when she received her commission for *Newsprint* she had recently added a new approach to narrative photography to her repertoire: documentary. As she traveled through the southern United States in the spring and summer of 1936 working with Erskine Caldwell on their first collaborative project, she developed an approach to narrative that hybridized her advertising background with her journalistic work for *Fortune* and *Life*. Caldwell and Bourke-White had a story to tell and they sought pictures to tell that story. They emphasized plausible reality; a scene needed to be plausibly real to be effective for their purposes. In the case of *You Have Seen Their Faces*, that purpose was to show the plight of sharecroppers in the

southern United States. In her autobiography Bourke-White dedicates a chapter to the book's creation and comments not just on its success, but its effectiveness. "Now the book had a life of its own and was no longer a personal thing. It had grown bigger than the two of us. Already it was reaching out, influencing others, and soon was to influence some United States legislation, a source of quiet pride to both of us."[94] Bourke-White felt they served a humanitarian purpose with this book, and the desire to do so began in 1936 when she and Caldwell began their work.

The book, published in the fall of 1937 after her second trip through the South with Caldwell that spring, contains text by Caldwell and photographs by Bourke-White—both telling the story of living conditions for the southern rural poor. They wrote the captions for the pictures together, and they appear below the pictures as though they were the words of the people in the photographs. But Caldwell and Bourke-White printed a disclaimer specific to the captions. "The legends under the pictures are intended to express the authors' own conceptions of the sentiments of the individuals portrayed; they do not pretend to reproduce the actual sentiments of these persons."[95] Therein lies the chief characteristic of documentary as practiced by Bourke-White; not that it reflects reality, but that it reflects a version of reality. Maren Stange writes, "Not the photograph alone . . . but the image set in relation to a written caption, an associated text, and a presenting agency . . . constituted the documentary mode."[96] In their book, all three definitive elements were present, allowing us to consider the images in the context of Caldwell's text, their captions, and the purpose of their book.

With plates 28–32 we have no such luxury. They were never published so we have neither captions nor an agency to consider, only the photographs. Nothing structural distinguishes this body of work from the rest of the work she did on this commission; they are printed on the same photographic paper, stamped "A Margaret Bourke-White Photograph" on the back (as were all the prints destined for the commission) and can be documented as having been made during her May 1937 trip. Only their subjects set them apart. In plates 28 and 29 Bourke-White shows a family and their house. In her notes, she identifies the father as Joseph Seguin, a foreman who cuts hardwood, his wife and children—the eldest daughter, Marion, stands in back and can be seen at the door in plate 28.[97] Their cabin appears well kept if simple, in marked distinction to the veritable shanties she photographed in the southern United States. The family—with the notable exception of the mother who studiously applies shortening to her biscuit—obliges the out-of-town photographer by posing in different positions around this room. Bourke-White portrays the family with respect; they live an austere, but not impoverished, life. This foreman was perhaps chosen by the company to represent the workers. Certainly these images were made while traveling with an International Paper guide in a plane the company provided. It seems likely that the company exerted some degree of preselection in terms of her subjects.

A portrait of a saint is prominently displayed on the wall in plate 29, recalling again the strong Catholic character of many of the people associated with logging in Quebec. To further explore this subject, the photographer visited the *Sainte Thérèse de l'Enfant Jesus* church in the village of Sainte Famille d'Aumond, the sign which she portrayed in plate 32.[98] Religious signs played an important role in *You Have Seen Their Faces*, though usually as ironic jabs at the faithful. In this sign, she seems to have been taken by the understated simplicity of its message and treats this subject with a gentle respect that carries over to the pictures taken in the church. In plate 30, the well-dressed girls are carefully choreographed, with their hands folded in prayer. And in plate 31 she works in collaboration with the priest and altar boys to create this image of the altar with its candles and electric light—the Machine Age coexisting gently with the world of candles. This

altar typifies Bourke-White's profound ambivalence in the spring of 1937 by showing the new technology of the electric lights working together with humble candlelight.

Ultimately this last group of images relates to Bourke-White's attempt to temper her famous enthusiasm for technology. The technological sublime had become increasingly tainted by the support it received from fascist governments in Europe in the late 1930s. As the historian John M. Jordan recently observed of the period:

> Opposition quickly mounted to technocratic, social scientific, and managerial control of American economic and social life. In a transatlantic political context, many intellectuals— some formerly committed advocates of scientism and its associated possibilities—began to compare technocratic reform with the marching dictatorships that often validated their domination with science.[99]

Bourke-White's problem, along with a host of other artists and thinkers, was how to balance modernity with antifascism. She was mildly political in this period, lending her name to the letterhead of several left-leaning organizations without ever getting very involved. As her biographer describes her at this point, "She had a conscience but not an ideology, a moral position but insufficient angst or political fervor to be a party member."[100] Her photography and her career came first; she avoided overt political acts.

The one exception was the American Artists' Congress, which formed in 1936 to protect artists' rights and to battle the suppression of freedoms under fascist leadership in Europe.[101] Bourke-White joined and participated in the activities of this history-making organization. She even addressed the hundreds of members present at their first meeting in New York City's Town Hall. In her speech she described the Soviet Union as a haven for artists because they enjoyed the "freedom to experiment" and had ample audiences for their work.[102] "Who are the audiences of artists in this country?" she continued. "If the artist is a commercial illustrator, his audience includes everyone who reads the current magazines and newspapers. But rarely do the limitations imposed upon the artist in commercial work permit him to do a free creative job."[103]

Margaret Bourke-White's documentary work for *Newsprint* emerged from her desire to approach her commission as she did a "creative job" like *You Have Seen Their Faces*. These photographs also reflect her politics at that time—1936–38. In making these pictures, she balanced modernity with a humanism that aligned her with the antifascist art world represented by the American Artists' Congress. Simply by making these pictures, she extended her personal reexamination that had accelerated since meeting Caldwell. The workers' lives deserved attention, consideration, perhaps even justification. Her politics were subtle and she worked from within the system of industrial commerce, but with this last suite of photographs, Bourke-White was making a quiet, personal attempt at political statement. She knew they might get published, even if not in *Newsprint,* and sought, for the sake of a vague, antifascist crusade, to effectively wield the power of paper.

Notes

1. By 1937 Canada produced about 45 percent of the world's newsprint, compared to the 10.5 percent produced in the United States. Clearing House, Department of Mass Communication, "Newsprint Trends, 1928–1951," *Reports and Papers on Mass Communication* 10 (U.N.E.S.C.O.) (February 1954): 11.

2. International Paper Sales, *Newsprint: A Book of Pictures Illustrating the Operations in the Manufacture of Paper on Which to Print the World's News* (Montreal: International Paper Sales Co., c. 1939). The book is not dated. Many of the library copies were acquired in 1939, and hence dated "c. 1939," but the company had the photographs by the fall of 1937, so a publication date of 1938 is not entirely out of the question.

3. The Otis Steel Company, for example, published a book with ten photogravure reproductions of Bourke-White photographs spaced through a text of about eighteen further pages. See *Otis Steel Company-Pioneer* (Cleveland, Ohio: Otis Steel Company, 1929). For more on Bourke-White's Otis Steel photographs see my essay, "A 'United States of the World': Industry and Photography Between the Wars," in *From Icon to Irony: German and American Industrial Photography* (Boston: Boston University Art Gallery and Seattle: University of Washington Press, 1995): 17–25.

4. Margaret Bourke-White, *Eyes on Russia* (New York: Simon and Schuster, 1931); Erskine Caldwell and Margaret Bourke-White, *You Have Seen Their Faces* (New York: Viking Press, 1937).

5. Bourke-White received a staggering $4,600 plus expenses. See W. A. Von Hagen, letter to Margaret Bourke-White, New York, 28 October 1937, Margaret Bourke-White Papers, George Arents Research Library, Syracuse University (hereafter M B-W Papers). In her submission for expenses she mentions a second trip in July 1937, a probability as she was then on her way to the Canadian Arctic on assignment for *Life* that month. Margaret Bourke-White, "Travelling Expenses," letter to W. A. Von Hagen, New York [Fall 1937], M B-W Papers and see Vicki Goldberg, *Margaret Bourke-White: A Biography* (Reading, Mass.: Addison Wesley, 1986): 199.

6. The photographic credits are printed on the last page of *Newsprint*; they start with credit to Bourke-White, her name in all upper case letters: "Photographs by MARGARET BOURKE-WHITE," then the following line, in considerably smaller script and with normal distribution of upper and lower case letters, reads: "and also H. F. Kells, Edward J. Herbert, Dominion Forest Service, and Associated Screen News."

7. "Paper and Power," *Fortune* 1 (May 1930): 65–72.

8. See "Portfolio on Paper: Driving Logs from Forest to Factory," *Life* 3 (5 July 1937): 24–29 and "Economics of Paper," *Fortune* 16 (October 1937): 110–113. The *Fortune* essay was the first of a three-part series on paper production that concluded with an update on International Paper and Power in the third essay. See "International Paper and Power," *Fortune* 16 (December 1937): 130–136.

9. On defining modernity, Terry Smith writes of "…the presence of a visual order which organizes seeing in particular ways, despite the limited scope of its imagery and its structural fragility.…It grew from being an iconography—a repetition of images—to become an iconology.…That is, these images…secured increasingly ordered patterns of reading from those consuming them, while at the same time modifying other modes, even displacing them, until the new regime of seeing became itself the norm." Terry Smith, *Making the Modern: Industry, Art, and Design in America* (Chicago: University of Chicago Press, 1993), 7–8.

10. Margaret Bourke-White, quoted in E. A. Batchelor, "Personal and Confidential: Margaret Bourke-White," *Detroit Saturday Night,* 10 May 1930: n.p., Clippings File, M B-W Papers.

11. Margaret Bourke-White, untitled typescript of NBC radio broadcast, 5 January 1932, M B-W Papers. This typescript includes parts of the same quote she gave to E. A. Batchelor for his article; see note 10. She gave the same basic text to other interviewers in the early 1930s as well. For this reason, I refer to the text as a credo of sorts, which she refined little between 1929 and 1934.

12. Margaret Bourke-White, *Portrait of Myself* (New York: Simon and Schuster, 1963), 110.

13. See T. J. Jackson Lears, *No Place of Grace: Anti-Modernism and the Transformation of American Culture, 1880–1920* (New York: Pantheon Books, 1981). The complaints continued through the 1920s as the chorus became international. In a 1927 book published in New York, the German philosopher Richard Müller Freienfels described the deplorable state of America as mechanized, standardized, and quantified, "even the people impress one as having been standardized. All these clean-shaven men, all these girls, with their doll-like faces, which are generally painted, seem to have been produced somewhere in a Ford factory, not by the dozen but by the thousand." Richard Müller Freienfels, *The Mysteries of the Soul* (New York: Alfred A. Knopf, 1927), 258.

14. Theodore M. Brown, *Margaret Bourke-White, Photojournalist* (Ithaca, NY: Andrew Dickson White Museum of Art and Cornell University, 1972), 52.

15. Margaret Bourke-White, "And So My Ship Came In," typescript by William McGarry of address at the National Press Club [1937], 5, M B-W Papers; published as Margaret Bourke-White and William McGarry, "Your Business as the Camera Sees It," *Nation's Business* (April 1938): 30–32, 96.

16. Margaret Bourke-White, "And So My Ship Came In," 5.

17. She commented in a typed biographical sketch that "In one month last winter I was in Texas, New York and Northern Canada on different assignments." Margaret Bourke-White, typescript, undated, M B-W Papers, unpaginated. We know that she left on the Texas trip at the end of December 1929. Alan Jackson, letter to Bourke-White, 19 December 1929, M B-W Papers. Thus the likely date of Bourke-White's trip for the International Paper story is January 1930.

18. Margaret Bourke-White, letter, undated, unpaginated, M B-W Papers. This letter was written as a response to a request for biographical information as it starts: "I understand that you want some kind of a biographical sketch." It was most likely written in the spring of 1930, as she mentions having already been to Texas and Canada (winter 1929–30) but is "looking forward" to her trip to Germany and Russia (summer 1930).

19. Dorothy Butler Sheldon, "Margaret Bourke-White Photographs: The Machine Age," unpublished typescript [c.1932], 7, M B-W Papers.

20. "Power and Paper," *Fortune* 1 (May 1930): 65–72.

21. Theodore Brown maintains, in a discussion of an article in that first issue of *Fortune*, but clearly applicable to many of the early articles, that it had "the rudimentary characteristics of the, as yet unformulated, photographic essay." Brown, *Margaret Bourke-White, Photojournalist*, 36.

22. Robert Brady, "The Meaning of Rationalization: An Analysis of the Literature," *Quarterly Journal of Economics* 46 (May 1932): 527.

23. "Power and Paper," 65.

24. Bourke-White rarely printed her own work. Early on in her career she had rationalized the production of her images into a system of mass production. While on location in distant locales, she could have her film delivered to her New York studio where it was developed, printed, evaluated, and sent on to the commissioning party.

25. Thorstein Veblen, *The Theory of Business Enterprise* [1904] (New York: Augustus M. Kelly, Bookseller, 1965): 6.

26. Ibid., 5.

27. Though Veblen published his most influential work between 1899 and 1919, the real impact of his ideas was not witnessed until the 1930s. One author noted in 1933: "With every evidence that a Veblen revival is well under way, the professors are…marveling at how accurately he laid those lean, workmanlike hands of his upon the inner processes of our industrial civilization….They find that a great part of what is still regarded as pioneering in 1933, was done by Veblen in his brilliant *The Theory of the Leisure Class,* first published in 1899, in *The Theory of Business Enterprise,* which he published five years later, and in *The Instinct of Workmanship,* which appeared in 1914." McAlister Coleman, "Veblen Comes Back," *The World Tomorrow* 16 (11 January 1933): 35.

28. Writing in 1932, George Boas apologized for taking up the subject. "So much has been written about machines and the Machine Age that the very words are taboo in polite conversation….But so much that has been said on the subject is muddled or beside the point or both, that one who is interested in the analysis of ideas may be pardoned perhaps for continuing the conversation, even though the audience gets up and leaves when he begins." George Boas, "In Defense of Machines," *Harper's Monthly Magazine* 165 (June 1932): 93.

29. Gerald Stanley Lee, *The Voice of the Machines: An Introduction to the Twentieth Century* (Northampton, Mass: The Mount Tom Press, 1906): 14–15.

30. I borrow this phrasing from Karen Lucic, *Charles Sheeler and the Cult of the Machine* (Cambridge, Mass: Harvard University Press, 1992), 9.

31. For more on the differences between the Stieglitz group and that centered on Arensberg, see Abraham A. Davidson, *Early American Modernist Painting, 1910–1935* (New York: Harper & Row, 1981), 13–116.

32. Except in cases of public amazement and ridicule as that which followed the Armory Show in 1913, see Milton Brown, *The Story of the Armory Show* (New York: Abbeville Press, 1988), 133–52.

33. Karen Lucic has identified these as the three characteristic subjects of the machine-age style. Lucic, *Charles Sheeler and the Cult of the Machine,* 34.

34. Her mother and brother lived in Cleveland Heights—they had moved there in 1923, the year after Margaret's father died. Margaret moved there after graduating from Cornell (her third university) in 1927 to be close to her mother and brother. Vicki Goldberg, *Margaret Bourke-White,* 23, 39, 66.

35. Goldberg, *Margaret Bourke-White,* 76. Trade Winds carried a Bourke-White on the cover each month until the end of its publication nearly five years later.

36. Wilson Hicks, *Words and Pictures: An Introduction to Photojournalism* (New York: Harper, 1952), 42.

37. Her assistant wrote: "I called Mr. Von Hagen and told him that it has been arranged for him to see Mr. Longwell. He thanked us and said that he would call back when he was ready for a definite appointment." Margaret Smith, letter to Margaret Bourke-White, New York, 12 April 1937, M B-W Papers.

38. "Portfolio on Paper: Driving Logs from Forest to Factory," *Life* 3 (5 July 1937): 24–29. Though her first trip was made for *Fortune,* as a sister publication *Life* had access to *Fortune's* photography archive and frequently made use of it during the early years of production.

39. "Economics of Paper," *Fortune* 16 (October 1937): 110–13.

40. By 1937 Bourke-White worked on *Life* when she worked for Luce. She had made no measurable contribution to *Fortune* since 1935, and the photographs that did show up in *Fortune* in 1937 were related to her work at *Life*.

41. She did not receive the commission right away, as she sent a letter of clarification to Von Hagen in mid-February explaining her quoted price and discussing other preliminaries. Margaret Bourke-White, letter to W. A. Von Hagen, New York, 12 February 1937, M B-W Papers.

42. In March, Von Hagen thought he might have enough images from her first trip in 1930. Bourke-White's secretary corresponded with her while she was on the road; she was in Natchez, Mississippi, when she received the news that she would not need to go to Canada. See Margaret Smith, telegram to Margaret Bourke-White, New York, 12 March 1937, M B-W Papers. But in the following week's correspondence, Smith wrote: "It looks like the International Paper job can be cleared up in about a week now and Mr. Von Hagen is waiting eagerly for a definite date when you can do it." Margaret Smith, letter to Margaret Bourke-White, New York, 19 March 1937, M B-W Papers.

43. Her uncle Lazar had long been a supporter of hers, even paying her college tuition after the death of her father. See Goldberg, *Margaret Bourke-White,* 24. In addition to her 1930 trip to International's operations, she made a 1932 or 1933 trip to logging operations on the Saguenay River in Quebec. She mentioned this second trip to a writer in 1934. See Helen McLean Sprackling, "Child of Adventure," *Pictorial Review* (December 1934): 4. Pictures from this second trip were reproduced along with images from International Paper and from Oxford Paper (in Rumford, Maine) in a *New York Herald Tribune* photography spread in 1933. See "A Pictorial Survey of the Paper Making Industry from Forest to Mill," *New York Herald Tribune* (31 December 1933).

44. The merging companies included: Glens Falls Paper Mill Company, Hudson River Pulp and Paper Company, Otis Falls Pulp Company, Glen Manufacturing Company, Niagara Falls Paper Company, Rumford Falls Paper Company, Falmouth Paper Company, Winnipiseogee Paper Company, Umbagog Paper Company, Russell Paper Company, Haverhill Paper Company, Herkimer Paper Company, Ontario Paper Company, St. Maurice Lumber Company, Turners Falls Paper Company, and the Montague Paper Company. W. E. Haskell, *The International Paper Company, 1898–1924* (New York: International Paper Co., 1924), 7.

45. L. Ethan Ellis, *Print Paper Pendulum: Group Pressures and the Price of Newsprint* (New Brunswick, N.J.: Rutgers University Press, 1948), 25.

46. A timber lease meant that the company did not own the land but rather the trees that grew on the land. They basically owned the right to take everything from six inches above the ground to the tops of the trees.

47. This practice began in Ontario in 1900, but was soon followed by Quebec in 1910, New Brunswick in 1911, and British Columbia in 1913. Herbert Marshall, Frank Southard, Jr., and Kenneth Taylor, *Canadian-American Industry: A Study in International Investment* (New Haven: Yale University Press, 1936), 36–37.

48. Marshall, Southard, and Taylor, *Canadian-American Industry,* 37.

49. "International Paper and Power," *Fortune* 16 (April 1937): 134–135.

50. Ibid., 135.

51. Frank Luther Mott, *American Journalism: A History of Newspapers in the United States Through 260 Years: 1690–1950,* revised edition (New York: MacMillan Company, 1950), 600–601.

52. "Power and Paper," *Fortune* 1 (May 1930): 69.

53. Newsprint demand rose at an average annual rate of 7 percent between 1913 and 1928, but between 1925 and 1926, for example, the increase was 18 percent; a jump Isaac Marcosson attributed directly to the increase in size of newspapers, largely to accommodate increased advertising. Isaac F. Marcosson, "The American Stake in Canada," *The Saturday Evening Post* (17 March 1928): 15.

54. "International Paper and Power," *Fortune,* (December 1937): 133. In one widely reported incident, International Paper stood up to the rest of the Canadian paper industry, which had united in an effort to impose price controls. In its contract with Hearst—not one lightly tinkered with—International had guaranteed a fixed price and, as was their policy, offered the same price to all their buyers. When the other newsprint manufacturers agreed to a universal price increase, International could not follow. The Canadian government tried to enforce the ruling, but International threatened to leave. By this time International's power division was the second largest source of electricity in Canada… the price controls did not survive. "Power and Paper": 70; John A. Guthrie, *The Newsprint Paper Industry* (Cambridge, Mass.: Harvard University Press, 1941), 107–12; and *Gatineau Power Company* (Ottawa, Canada: Gatineau Power Company, July 1927): 12.

55. Kraft paper refers to a variety of strong, heavy papers used for wrapping and in the construction of containers. The term comes from the German word *kraft,* meaning strength —the technique for producing kraft was developed in Germany in the 1890s. *International Paper Company After Fifty Years* (New York: International Paper Company, 1948): 65.

56. "Power and Paper," 65.

57. The two nations produced 4,485,000 metric tons of newsprint in 1937, compared to the decade's lowest point in 1932, the worst year of the Depression, when the combined production level had fallen to 2,898,000 metric tons. Clearing House, Department of Mass Communication, "Newsprint Trends, 1928–1951," 13.

58. *International Paper Company,* (New York: International Paper Company, 1901).

59. W. B. Haskell, *The International Paper Company, 1898–1924: Its Origin and Growth in a Quarter of a Century with a Brief Description of the Manufacture of Paper from the Harvesting of Pulpwood to the Finished Roll* (New York: International Paper Company, 1924).

60. International Paper Company, *International Paper Company* (New York: International Paper Company, 1927): 3.

61. Schirmer, Atherton and Company, "International Paper Company," *Study in Values* 18 (15 June 1927): unpaginated.

62. See William Truettner and Alan Wallach, *Thomas Cole: Landscape into History* (New Haven, Conn.: Yale University Press, 1994). Albert Boime makes the related point that panoramic paintings of the mid-nineteenth century were linked, politically and socially, to the ideal of Manifest Destiny. See Albert Boime, *The Magisterial Gaze: Manifest Destiny and American Landscape Painting, c. 1830–1865* (Washington, D.C.: Smithsonian Institution Press, 1991).

63. *Newsprint* used a similar image to introduce the snowy forest, but one that included two lumbermen walking down the path.

64. For more on Dow and his teachings, see Frederick C. Moffatt, *Arthur Wesley Dow* (Washington, D.C.: National Collection of Fine Arts, Smithsonian Institution, 1977) and Nancy Green, *Arthur Wesley Dow and His Influence,* (Ithaca, N.Y.: Herbert Johnson Museum, 1990).

65. On the "culture of consumption" I am in particular thinking of T. J. Jackson Lears's discussion of consumption's role in shaping American culture. See T. J. Jackson Lears, "From Salvation to Self-Realization: Advertising and the Therapeutic Roots of the Consumer Culture, 1880–1930," in *The Culture of Consumption,* ed. Richard Wightman Fox and T. J. Jackson Lears (New York: Pantheon Books, 1983).

66. In an attachment to a letter to Bourke-White, W. A. Delahey of Canadian International Paper Company identifies the location of this camp as Wahwati Depot. W. A. Delahey, "Key To Show Location Where Pictures Taken by Miss Bourke White on the Gatineau Operations on May 20th and May 21st 1937," undated attachment to his letter to Margaret Bourke-White, 31 May 1937, Maniwaki, Quebec, M B-W Papers.

67. According to W. A. Delahey, the timber slide photographs were made at Wasp Lake. Delahey, "Key to Show Locations," M B-W Papers.

68. Henri Cartier-Bresson, *The Decisive Moment* (New York: Simon and Schuster, 1952) quoted in Vicki Goldberg, *Photography in Print* (Albuquerque, N. Mex.: University of New Mexico Press, 1981), 385.

69. Herman Melville's Ahab (*Moby Dick,* 1851) established a literary image of the romantic figure whose raised harpoon would determine his destiny, just as John Singleton Copley had offered the pictorial version of a related figure in his *Watson and the Shark* of 1778 (Museum of Fine of Arts, Boston). The difference lay in whose destiny the harpooner controlled, but in both instances, the moment of the raised harpoon was a moment of great dramatic tension.

70. The logs that could not be used for newsprint (they used primarily spruce and fir) were separated out and sent to the sawmills and pulp plants.

71. Margaret Bourke-White quoted in Goldberg, *Margaret Bourke-White,* 145, and note p. 389.

72. Margaret Bourke-White, "Calendar," c. 1955, M B-W Papers.

73. For more on the history of aerial photography, see Beaumont Newhall, *Airborne Camera: The World from the Air and Outer Space,* (New York: Hastings House, 1969).

74. Captain Alfred Buckham, "Portfolio," *Fortune* 1 (April 1930): 75–79. This issue was dedicated to aviation stories. The magazine commissioned Buckham the following year to take a series of aerial photographs around the world—they were published in October, November, and December 1931.

75. Editorial, *Fortune* 1 (April 1930): 18.

76. *International Paper Company After Fifty Years,* 41.

77. W. B. Haskell, *The International Paper Company, 1898–1924,* 13.

78. Isaac F. Marcosson, "The American Stake in Canada," *The Saturday Evening Post* (17 March 1928): 72.

79. *International Paper Company After Fifty Years,* 18.

80. By January 1929, International Paper's power plants could produce 380,018,000 kilowatt hours of electric energy. International Paper and Power Company, *Output of Electric Energy in January 1929* (New York: International Paper and Power Company, 1929): unpaginated.

81. "Power and Paper," *Fortune* (May 1930): 71.

82. As a separate corporation, Gatineau Power entered into a contract to sell electricity to Canadian International Paper; both companies had to be self-sustaining, profitable divisions of International Paper and Power. Gatineau Power also had contracts to sell electricity outside the company. Gatineau Power Company, *Gatineau Power Company* (Ottawa, Canada: Gatineau Power Company, July 1927), 5.

83. Ibid., 7.

84. Henry Adams, "The Dynamo and the Virgin," in *The Education of Henry Adams* (Boston: Massachusetts Historical Society, 1918, reprinted New York: Modern Library, 1931): 379–90.

85. Edward Garside, letter to Margaret Bourke-White, New York, 19 May 1939. She sent her response almost two months later. Margaret Bourke-White, letter to Edward Garside, 12 July 1939, New York, M B-W Papers.

86. Stuart Chase, "A Vision in Kilowatts," *Fortune* 7 (April 1933): 110.

87. Editor, "Note," *Fortune* 7 (April 1933): 110.

88. Graustein was asked to step down from International Paper, but when offered a position with International Paper and Power, in January 1936, he resigned. Cullen's presidency was announced in February of that year. "International Paper and Power," *Fortune* 16 (December 1937): 226.

89. "Eliminating IP&P," *Business Week* (9 August 1941): 65.

90. R. Austin Freeman, *Social Decay and Regeneration* (London: Constable and Co., 1921): 181. Among the others railing against the effect of technology on workers, see Aldous Huxley, "Machinery, Psychology and Politics," *The Spectator* (23 November 1929): 750.

91. We know that she traveled to Dalhousie during her 1937 trip because she mentions it specifically in her list of expenses and when another photograph from the same series was printed in *Life* it was so identified. See Margaret Bourke-White, "Travelling Expenses," letter to W. A. Von Hagen, New York [Fall 1937] and "Portfolio on Paper: Driving Logs from Forest to Factory," *Life* 3 (5 July 1937): 29.

92. Since 1925, when Canada supplied only 25 percent of the newsprint consumed in the United States, that percentage had been steadily increasing to the point where the proportion was reversed in 1939 and the U.S. produced only 25 percent of the newsprint it used. Clearing House, Department of Mass Communication, "Newsprint Trends, 1928–1951," 15; and L. Ethan Ellis, *Newsprint: Producers, Publishers and Political Pressures* (New Brunswick, N.J.: Rutgers University Press, 1960), 37–39.

93. This motif lasted as the company trademark until 1960 when the designer Lester Beall created a new corporate identity; he came up with the now familiar motif of the "I" and "P" merged as an abstracted tree inscribed in a circle. See R. Roger Remington, *Lester Beall: Trailblazer of American Graphic Design.* (New York: W. W. Norton, 1996), 120–29.

94. Margaret Bourke-White, *Portrait of Myself,* 138–39.

95. Erskine Caldwell and Margaret Bourke-White, *You Have Seen Their Faces* (New York: Modern Age Books, 1937). The disclaimer appears on the page spread before the first reproduction.

96. Maren Stange, *Symbols of Ideal Life: Social Documentary Photography in America, 1890–1950* (New York: Cambridge University Press, 1989), xiv.

97. Margaret Bourke-White, handwritten note, International Paper Folder, M B-W Papers.

98. W. A. Delahey, "Key to Show Location Where Pictures Taken by Miss Bourke White…," M B-W Papers.

99. John M. Jordan, *Machine-Age Ideology: Social Engineering and American Liberalism, 1911–1939* (Chapel Hill: University of North Carolina Press, 1994), 255.

100. Goldberg, *Margaret Bourke-White,* 158–59.

101. Matthew Baigell and Julia Williams, "Introduction," in Matthew Baigell and Julia Williams, eds. *Artists Against War and Fascism: Papers of the First American Artists' Congress* (New Brunswick, N.J.: Rutgers University Press, 1986), 34–35.

102. Margaret Bourke-White, "An Artist's Experience in the Soviet Union," in Baigell and Williams, *Artists Against War and Fascism,* 85. Vicki Goldberg discusses the naiveté of Bourke-White's analysis of the situation in the Soviet Union, but notes that "she hadn't the knowledge—and most Americans did not—to realize how wrong she was." Goldberg, *Margaret Bourke-White,* 158.

103. Bourke-White in Baigell and Williams, *Artists Against War and Fascism,* 86.

PLATE 1

Gelatin silver print
1930
13 ¼ x 9 ¼ inches

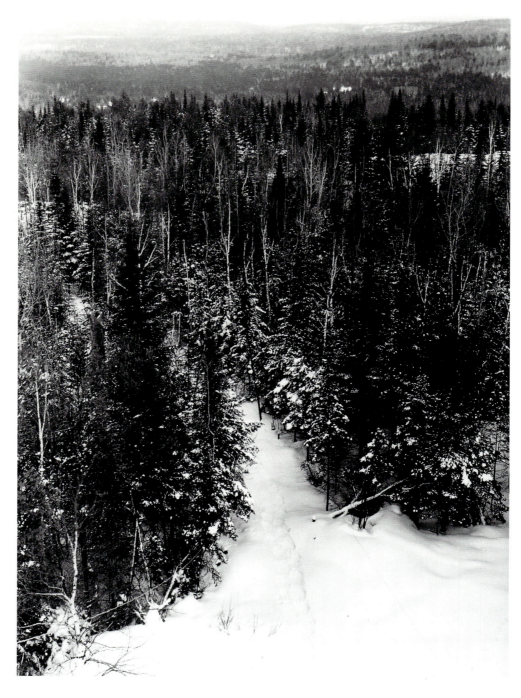

PLATE 2

Gelatin silver print
1930
9 ¹/₄ x 13 ¹/₄ inches

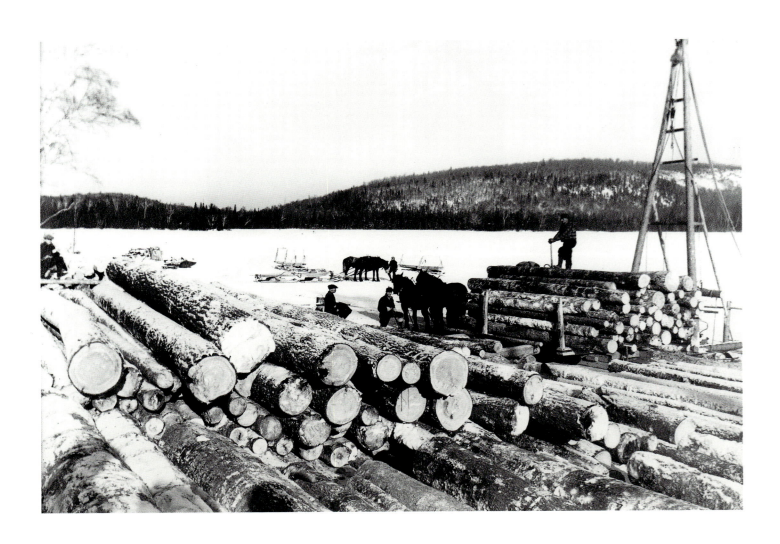

PLATE 3

Gelatin silver print
1930
13 ½ x 10 inches

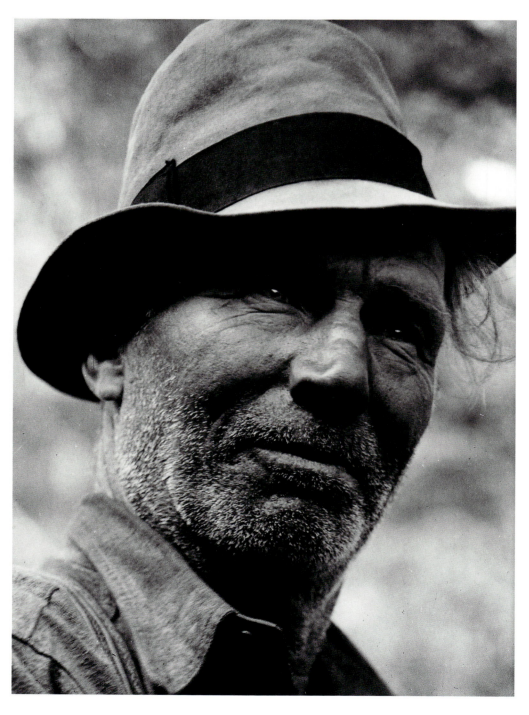

PLATE 4

Gelatin silver print
1930
13 ¹/₄ x 5 ³/₄ inches

PLATE 5

Gelatin silver print
1937
10 ¹/₄ x 13 ¹/₂ inches

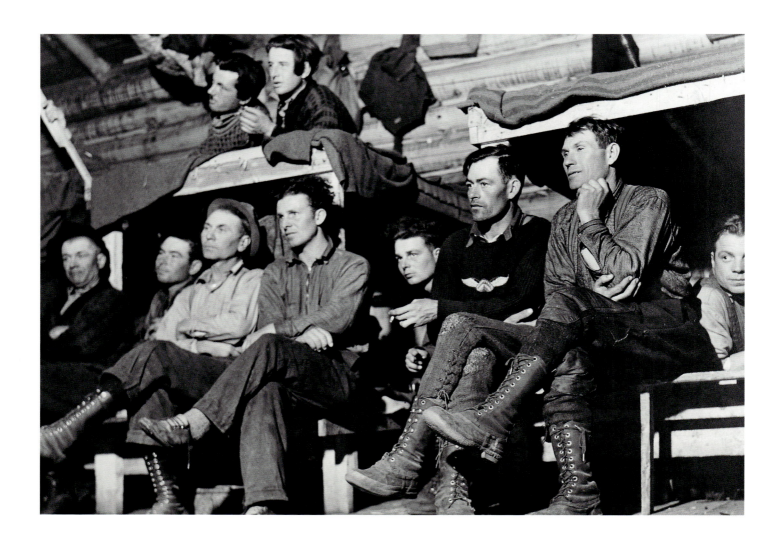

PLATE 6

Gelatin silver print
1937
10 $\frac{1}{4}$ x 13 $\frac{1}{2}$ inches

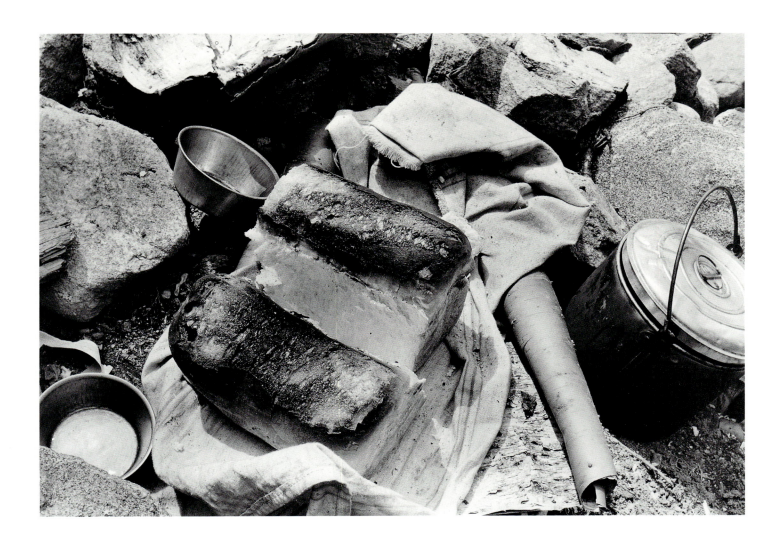

PLATE 7

Gelatin silver print
1937
13 ½ x 10 ¼ inches

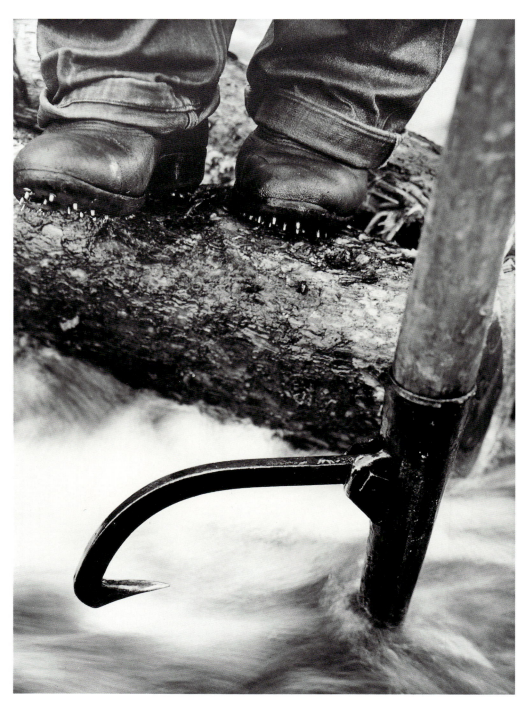

PLATE 8

Gelatin silver print
1937
10 $\frac{1}{4}$ x 13 $\frac{1}{2}$ inches

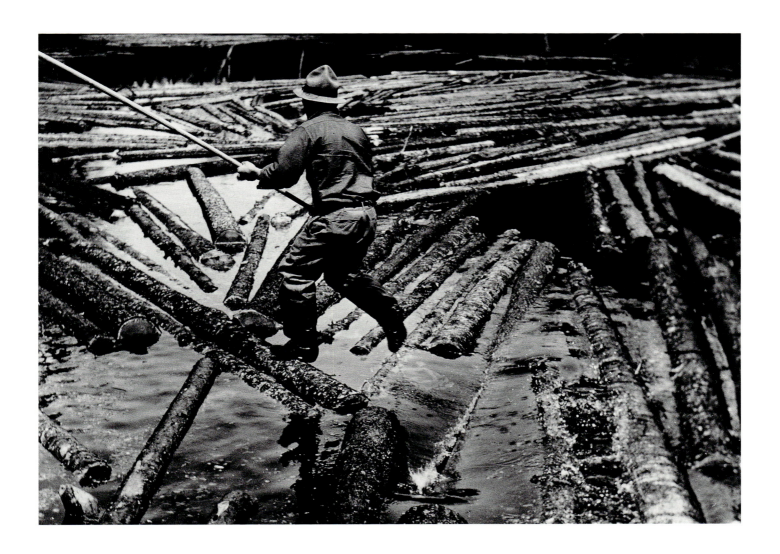

PLATE 9

Gelatin silver print
1937
13 $\frac{1}{2}$ x 10 $\frac{1}{2}$ inches

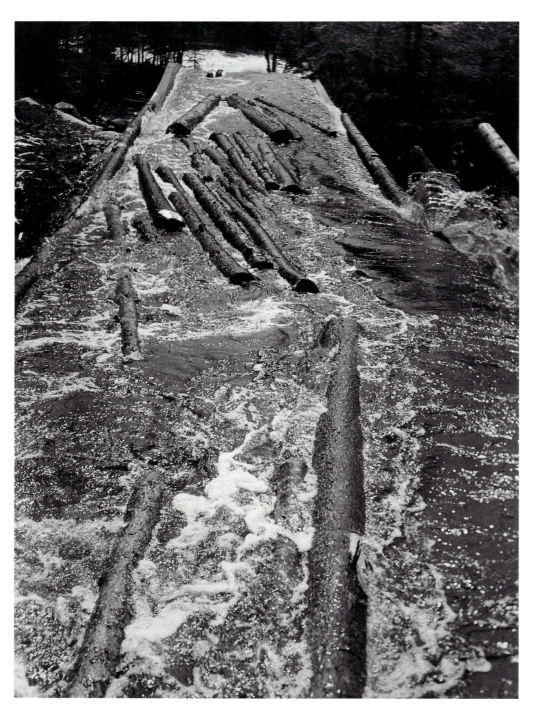

PLATE 10

Gelatin silver print
1937
10 x 13 ½ inches

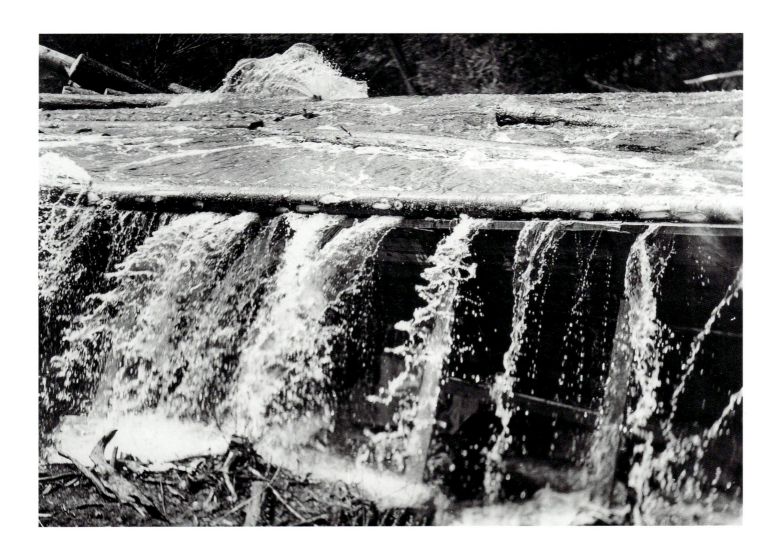

PLATE 11

Gelatin silver print
1937
9 ³/₄ x 13 ¹/₂ inches

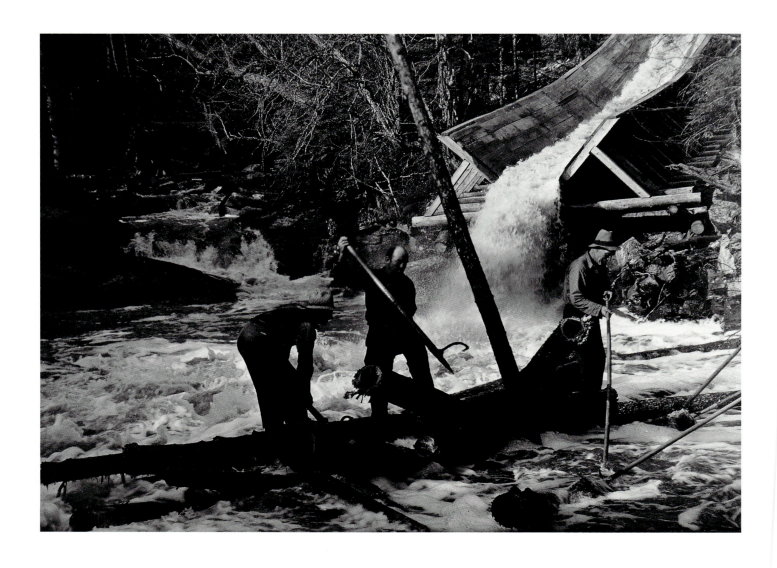

PLATE 12

Gelatin silver print
1937
9 ¾ x 13 ½ inches

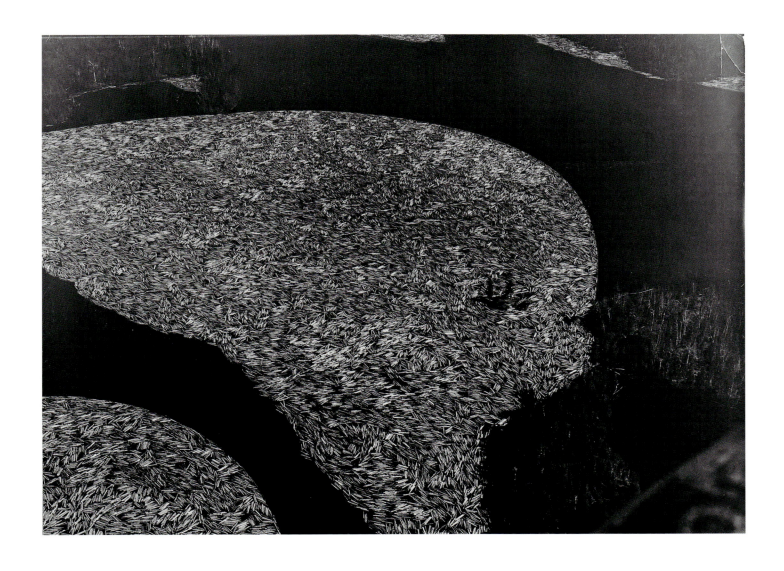

49

PLATE 13

Gelatin silver print
1937
10 ¹/₄ x 13 ¹/₂ inches

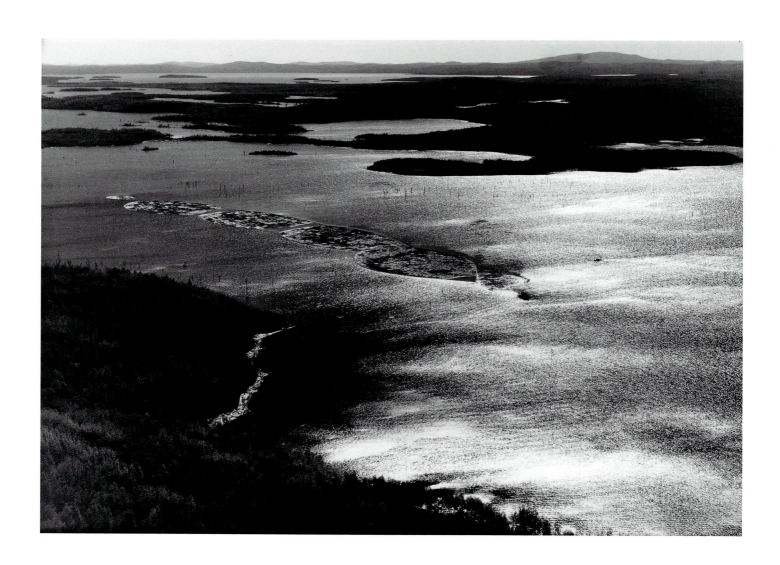

PLATE 14

Gelatin silver print
1937
10 ¹/₄ x 13 ¹/₂ inches

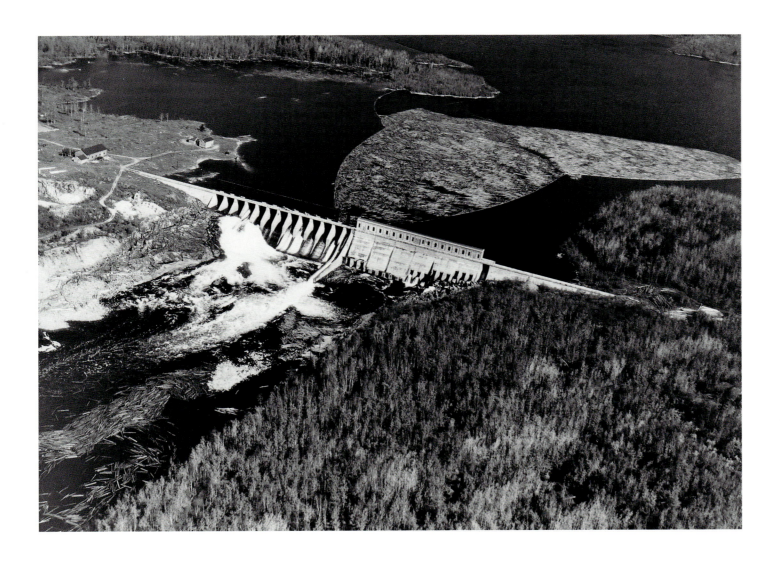

PLATE 15

Gelatin silver print
1937
10 ¹/₄ x 13 ¹/₂ inches

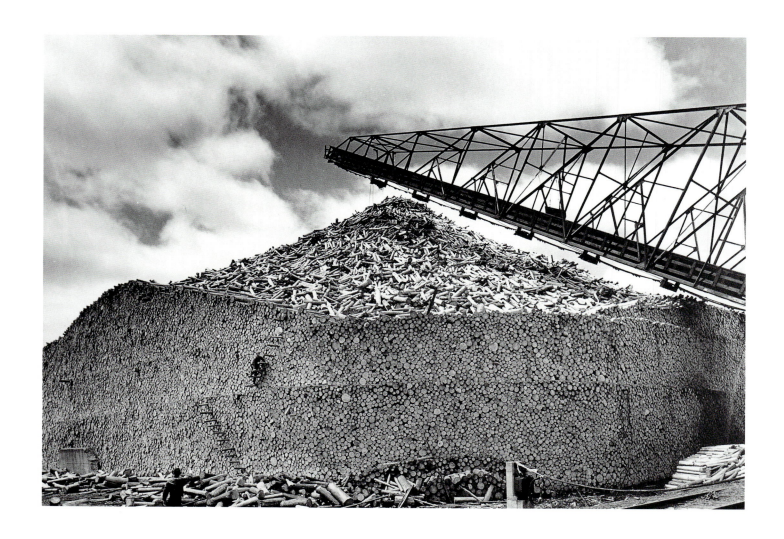

PLATE 16

Gelatin silver print
1937
13 ³/₄ x 10 ¹/₄ inches

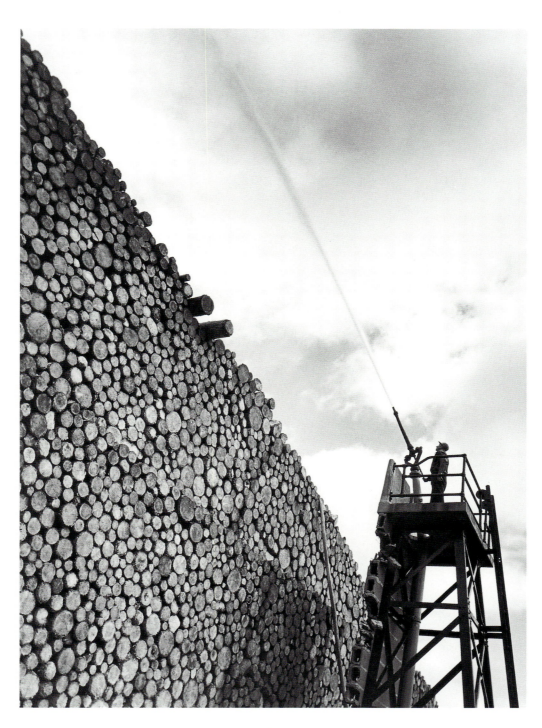

PLATE 17

Gelatin silver print
1937
10 $\frac{1}{4}$ x 13 $\frac{1}{2}$ inches

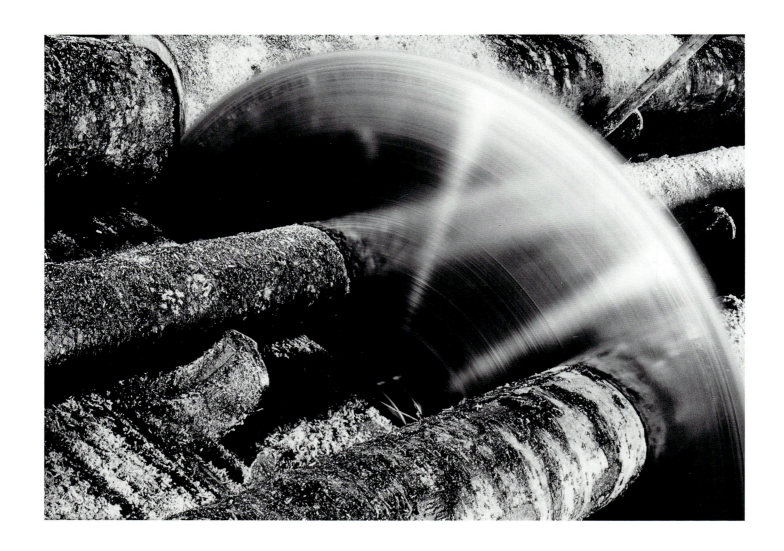

Gelatin silver print
1937
13 ½ x 10 inches

PLATE 18

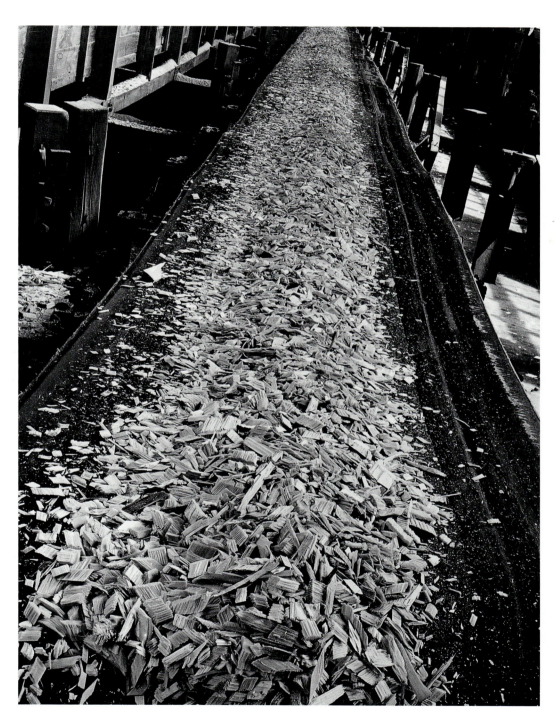

Gelatin silver print
1937
10 $\frac{1}{2}$ x 13 $\frac{3}{4}$ inches

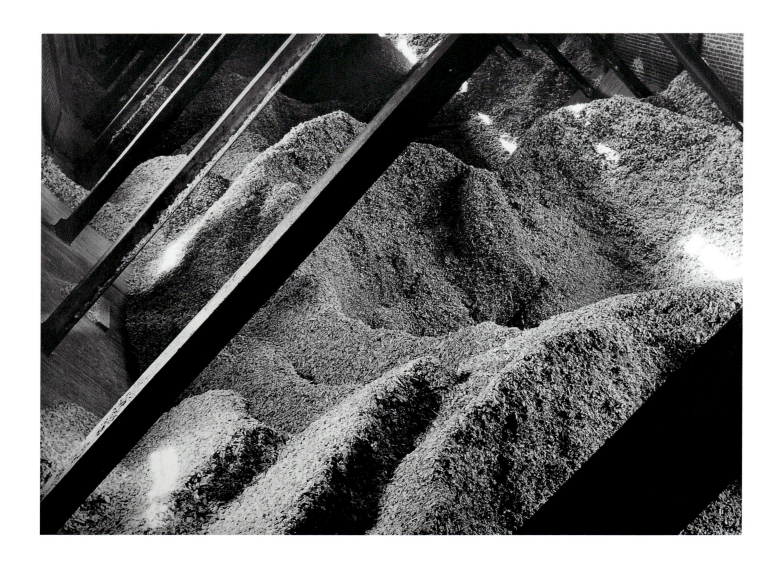

PLATE 20

Gelatin silver print
1937
10 x 13 ¹/₄ inches

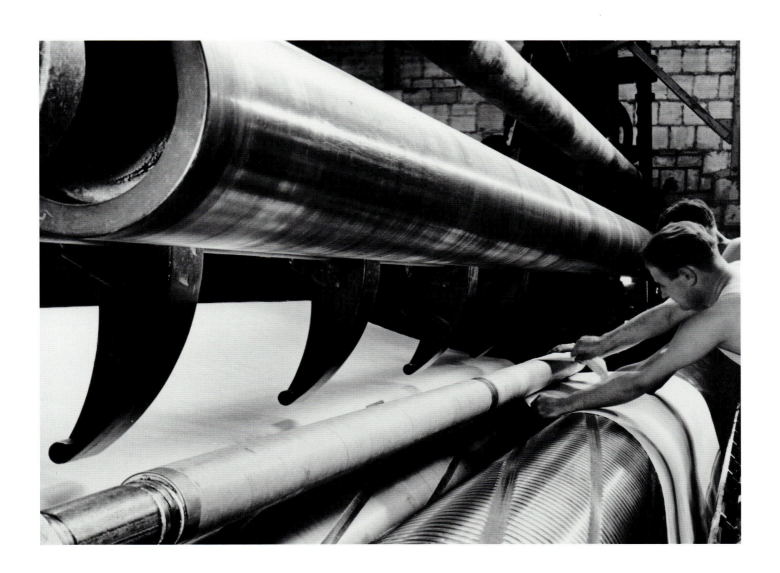

PLATE 21

Gelatin silver print
1930
3 x 12 ³/₄ inches

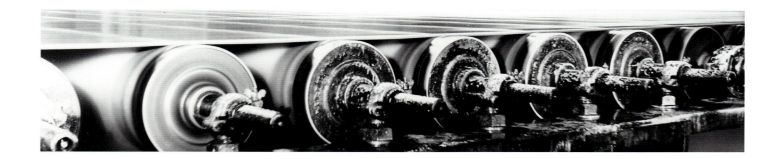

PLATE 22

Gelatin silver print
1930
13 ¹/₂ x 9 ¹/₂ inches

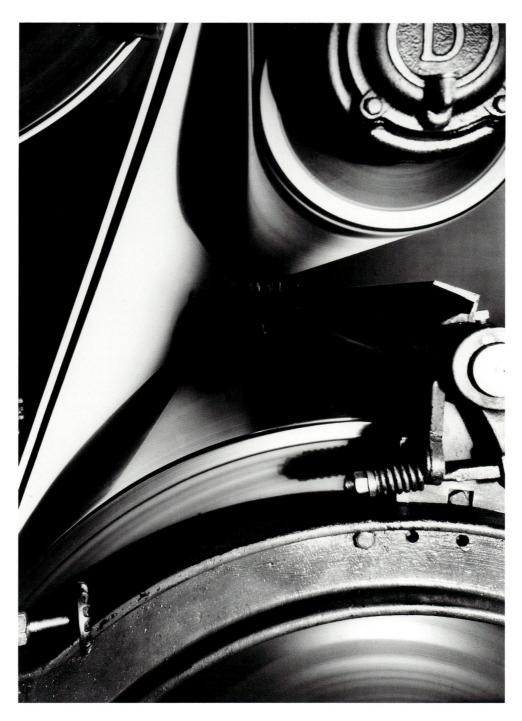

PLATE 23

Gelatin silver print
1937
10 x 13 ½ inches

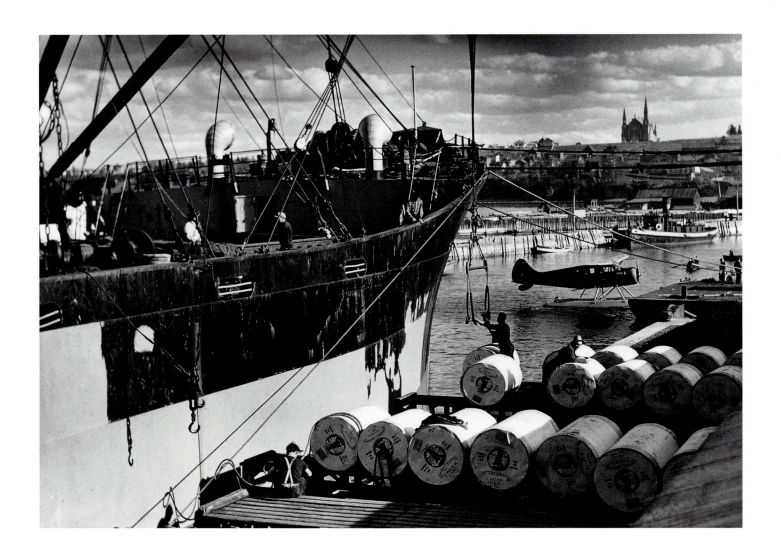

PLATE 24

Gelatin silver print
1937
13 ¼ x 10 inches

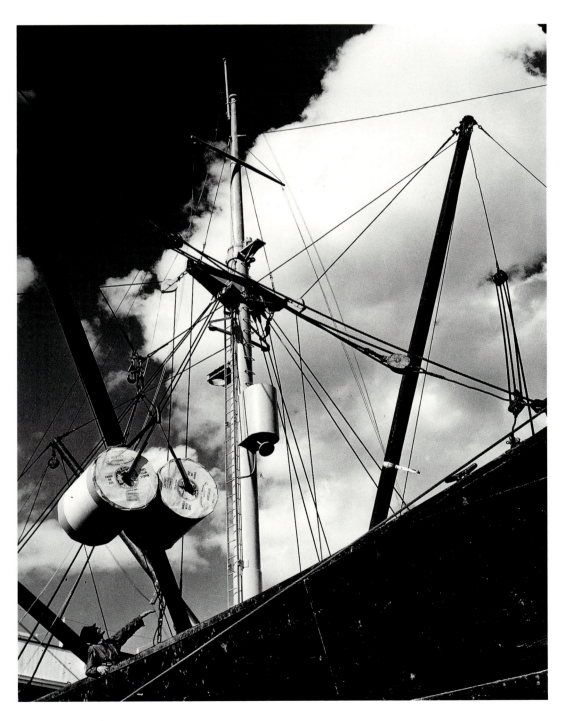

PLATE 25

Gelatin silver print
1930
13 x 9 ¼ inches

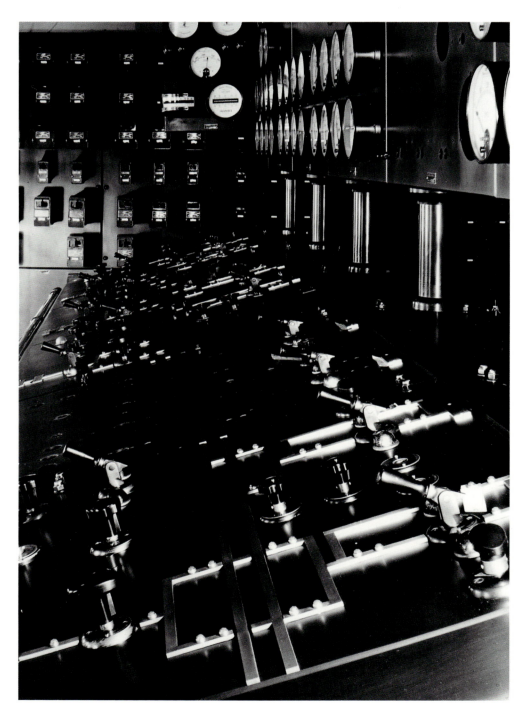

PLATE 26

Gelatin silver print
1937
13 ¹/₄ x 9 ³/₄ inches

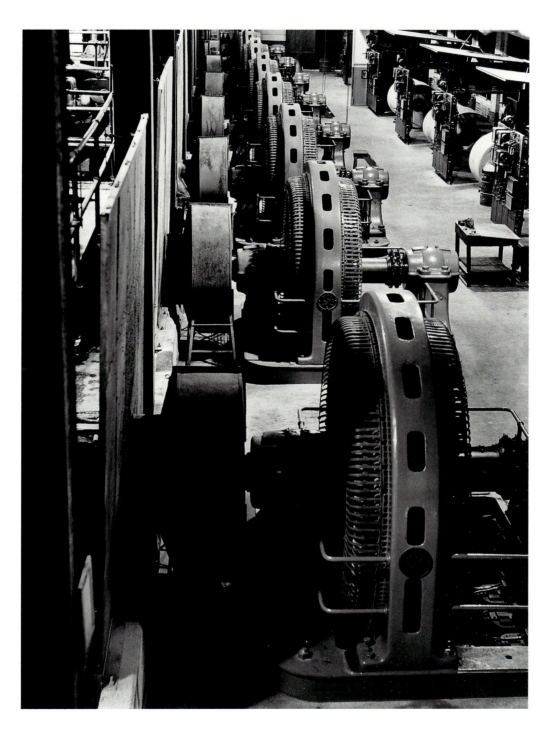

PLATE 27

Gelatin silver print
1937
13 ½ x 9 ¾ inches

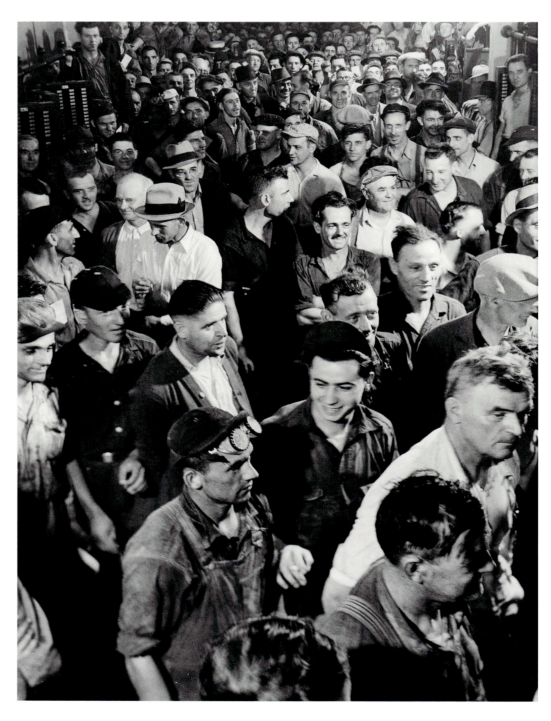

PLATE 28

Gelatin silver print
1937
10 $\frac{1}{4}$ x 13 $\frac{1}{2}$ inches

PLATE 29

Gelatin silver print
1937
10 $\frac{1}{4}$ x 13 $\frac{1}{2}$ inches

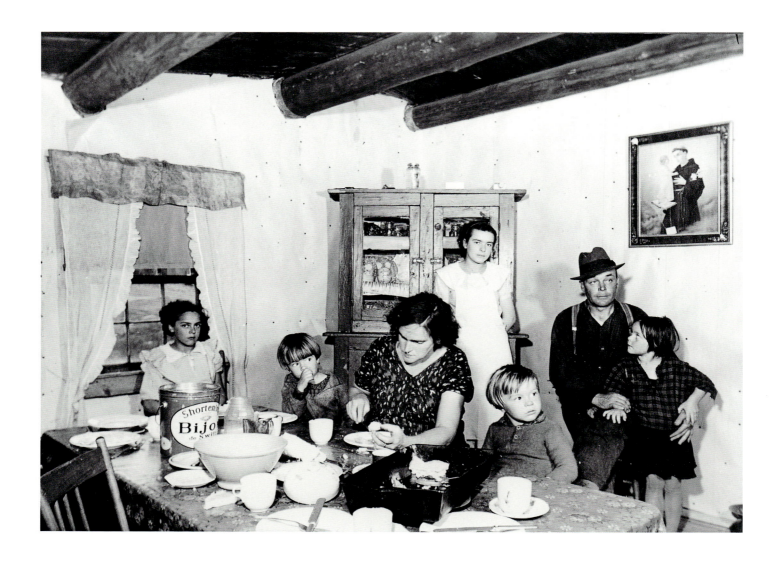

PLATE 30

Gelatin silver print
1937
10 ¹/₄ x 13 ¹/₂ inches

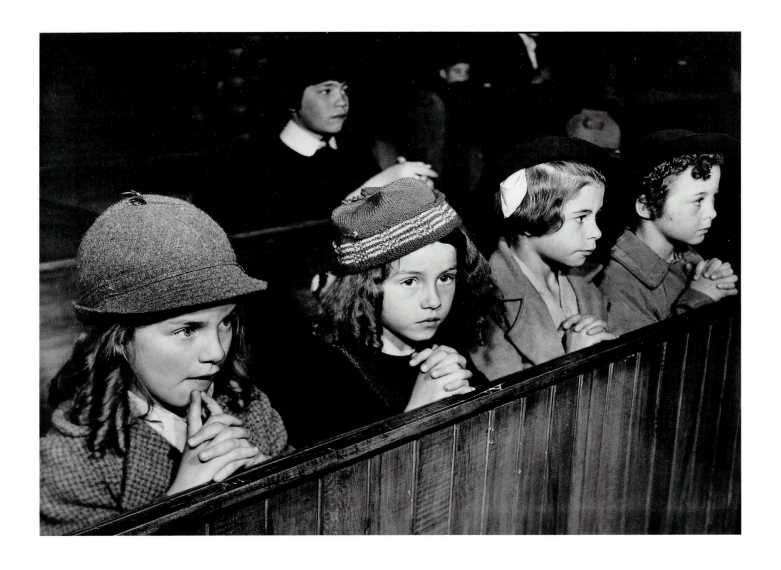

PLATE 31

Gelatin silver print
1937
13 ½ x 10 ¼ inches

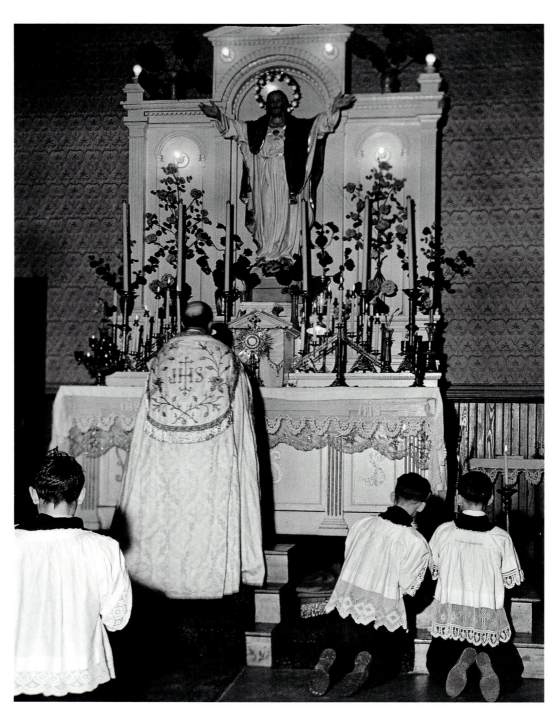

PLATE 32

Gelatin silver print
1937
13 ¹/₄ x 10 ¹/₄ inches

Chronology
Margaret Bourke-White

14 JUNE 1904	Born in New York City to Joseph and Minnie [Bourke] White. Childhood in Bound Brook, New Jersey.
SUMMER 1921	Attends summer school at Rutgers University at the age of 17.
FALL 1921	Attends Columbia University, the Clarence H. White School of Photography.
17 JANUARY 1922	Father dies.
1923–25	Attends University of Michigan, studies Biology, specifically herpetology.
1924	Marries engineering student Everett "Chappie" Chapman.
1925	Moves to Cleveland, works at Cleveland's Museum of Natural History.
1926	Leaves Chapman.
26 SEPTEMBER 1926	Enrolls at Cornell University, majoring in philosophy in the College of Arts and Sciences.
1927	Graduates from Cornell with B.A. Moves back to Cleveland.
1928	Photos begin to appear on the cover for *Trade Winds*.
18 FEBRUARY 1928	Divorce from Chapman finalized.
1928	Opens her studio in the Terminal Tower in Cleveland.
1929	Otis Steel Company publishes ten photographs.
SPRING 1929	Henry R. Luce of *Time* hires Bourke-White for *Fortune*.
1929	Moves to studio in New York City at the Chrysler Building.
JANUARY 1930	First trip to Canada for *Fortune*.
FEBRUARY 1930	First issue of *Fortune*.
1930	Trip to Russia and Germany.
1931	Publishes *Eyes on Russia*.
1931	Second trip to Russia.
1933	Executes mural commission for NBC studios in the RCA building.

1934	Publishes *USSR Photographs*.
1936	Begins work at *Life*.
3 JULY 1936	Mother dies.
23 NOVEMBER 1936	Cover photograph of the first issue of *Life*.
MARCH 1937	Works on *You Have Seen Their Faces* (1937) with Erskine Caldwell.
APRIL 1937	Travels to Canada to photograph the paper mills of International Paper and Power Company for *Newsprint*.
JULY 1937	Travels in Canada and the Arctic Circle with John Buchan (Lord Tweedsmuir) for *Life*. Possible second trip for International Paper.
MARCH–SEPTEMBER 1938	Travels in Europe—Spain and Czechoslovakia.
27 FEBRUARY 1939	Marries Erskine Caldwell.
1939	Publishes *North of the Danube* with Caldwell.
1941	Publishes *Say, Is This the USA?* with Caldwell.
1941	Works for the magazine *PM*.
1942	Publishes *Shooting the Russian War*.
NOVEMBER 1942	Divorces Caldwell.
1944	Publishes *They Called It "Purple Heart Valley."*
1945	Travels with Patton's Third Army when it liberates the German death camps.
1946	Publishes *Dear Fatherland, Rest Quietly*.
1946–48	Travels in India, photographs Gandhi just before his assassination.
1949	Publishes *Halfway to Freedom*.
1949–50	In South Africa, photographs mine workers three miles below the surface of the earth.
1951	Receives an honorary degree from the University of Michigan.
MID-1950S	Parkinson's disease makes it impossible to continue photographic work.
1963	Publishes *Portrait of Myself,* her autobiography.
1969	Retires from *Life*.
27 AUGUST 1971	Dies in Darien, Connecticut.

BOSTON UNIVERSITY

President: Jon Westling

Provost: Dennis D. Berkey

COLLEGE OF ARTS AND SCIENCES

Dean: Dennis D. Berkey

Chairman, Art History Department: Keith N. Morgan

SCHOOL FOR THE ARTS

Dean: Bruce MacCombie

Director, Visual Arts: Hugh O'Donnell

BOSTON UNIVERSITY ART GALLERY

855 Commonwealth Avenue

Boston, Massachusetts 02215

617/353-4672

Director: Kim Sichel

Assistant Director: John R. Stomberg

Security: Evelyn Cohen

Gallery Assistants: Amy Daughenbaugh, Katie Delmez, Riva Feshbach, Katrina A. Jones, Julie Marchenko, Andrew Tosiello, Francesca Tronchin

Catalogue Designer: Diana Parziale

Copy Editor: Eileen Dunn

Photographic Credits: Vernon Doucette, Boston University Photo Services

This catalogue is printed on Zanders Ikono Dull Satin, 100# cover/100# text, a recycled paper containing 20 percent post-consumer waste.